An Introduction to Electronic Imaging for Photographers

An Introduction to Electronic Imaging for Photographers

Adrian Davies and Phil Fennessy

Focal Press
An imprint of Butterworth-Heinemann Ltd
Linacre House, Jordan Hill, Oxford OX2 8DP

 A member of the Reed Elsevier plc group

OXFORD LONDON BOSTON
MUNICH NEW DELHI SINGAPORE SYDNEY
TOKYO TORONTO WELLINGTON

First published 1994

British Library Cataloguing in Publication Data
Davies, A.
 Introduction to Electronic Imaging for
 Photographers
 I. Title II. Fennessy, Phil
 621.36

ISBN 0 240 51384 3

Library of Congress Cataloging in Publication Data
Davies, Adrian.
 An introduction to electronic imaging for photographers/Adrian
 Davies and Phil Fennessy.
 p. cm.
 Includes index.
 ISBN 0 240 51384 3
 1. Images, Photographic. 2. Photography – Digital techniques.
 I. Fennessy, Phii. II. Title.
 TR222.D28 94–26994
 778–dc20 CIP

Composition by Scribe Design, Gillingham, Kent
Printed in Great Britain by Clays, St Ives plc

Contents

Compact disk – Information

Because every computer system is configured differently, results and success in using the accompanying CD-ROM may vary. Consult the manuals for your operating system and applications programs to ensure optimal conditions.

To access the disk you require the following equipment:

An Apple Macintosh with CD drive capable of reading XA ROM type disks and a monitor capable of showing thousands of colours*

Or

An IBM compatible computer 386, or faster, with CD drive capable of reading XA ROM session disks and a monitor capable of showing thousands of colours*

In order to run efficiently on a MAC or PC, Adobe Photoshop 3 requires at least 12MB RAM and a reasonable amount of hard disk space (preferably 50MB)

If your MAC does not have either MacWrite or Word software then the text documents can be read using the utility: TeachText. On a PC, convert the text to Write format.

*for users with 256 colours only, try opening images and converting to indexed colour using the Mode menu indexed colour option in Photoshop

Full instructions for accessing the disk appear at the end of this book and on the disk itself

Preface

A whole new vocabulary is starting to enter the world of photography, with terms like 'image grabbing', '24 bit TIFF', 'pixel cloning' and 'digital darkroom' being used increasingly in the press, often by people who do not fully understand their meaning. Photography is undergoing a revolution, as profound as when glass plates were replaced by acetate film. No longer are photographers reliant on darkrooms, and often poisonous chemicals to process their films. Images can now be recorded in digital form using conventional cameras fitted with special backs containing electronic silicon chips rather than film. Those images can be stored in electronic form, loaded into a computer where they can be enhanced, manipulated or analysed, transmitted down telephone lines or by satellite, and output directly to printing plates, or high quality paper printer. There is no fundamental change in the way pictures are taken – photographers still need the skills of lighting and composition, but they have now far greater control over the image. By the same token their role is changing; no longer are they *just* the photographer – they may be required to transmit the image via a computer, or produce the colour separations necessary for 4 colour printing. The barriers between printer, photographer and designer are becoming blurred.

This book explains the new technologies of electronic imaging in simple down to earth language. Starting with image capture, it looks at the advantages and disadvantages of electronic cameras. Conventional photographs can be loaded into computers by scanning them, and this is explored in detail. The computer has become ubiquitous over the last few years, and chapters devoted to computers themselves, the storage of data including PhotoCD and CD-ROM, are all written from a photographer's point of view. Image processing – the manipulation, enhancement and analysis of images is dealt with, as are various other types of computer program useful to photographers. A whole range of printers are now available, and these are examined, as well as the requirements for high quality output of images. A major area of interest at present is image transmission, a subject littered with technical jargon, which we have tried to cover in simple terms. Finally, much controversy exists about the ethical and legal implications of the new technologies, and these are discussed, with practical examples.

We are both photographers who have learnt the new technologies the hard way, picking up little bits of information from a variety of sources. We hope this book will go some way to putting some of that information all together in one place, and shows that the technology is not as difficult to understand

as many people assume. We believe it is essential for modern photographers to come to terms with it, and use it as another tool in their armoury for image production.

Adrian Davies and
Phil Fennessy

Acknowledgements

The authors would like to thank the following companies and individuals for their help and support during the preparation of this book.

John Henshall for the use of his retouching example and for advice and encouragement given over a number of years; Tony Eatough, Chris Cox and other staff from Kodak Ltd. Roger Ward, Richard Tunstall and Bruce Gray of NESCOT, for reading and commenting upon various sections of the book; Eric Joakim and Reuben Tompkins of Glenlake; Mark Middlebrook and Adam Woolfitt of Silicon Imaging; John Tinsley; John Darbey for providing the cover illustration; Letraset UK Ltd.; Adobe; Aldus UK; Rupert Grey for reading and advising on the legal chapter; San Gabriel Valley Publishing Company for permission to quote from their code of practice for imaging; Margaret Riley at Focal Press (Butterworth-Heinemann) for constant advice, enthusiasm and encouragement.

1 Introduction

In August 1981, the photographic world was shocked to see the announcement by the Sony Corporation of a revolutionary video still camera. This camera, the 'Mavica', was capable of recording 50 images on to small floppy disks, which could then be viewed instantly on a television set. Unwanted images could be erased, and new ones added. Whilst the camera caused a great stir at the time, it was some years before this type of 'still video' camera became widely available to photographers, and even then the results left much to be desired. However, the camera did spark off a great rush of research by many leading photographic and computing companies to develop electronic imaging systems, which might one day replace conventional photographic film.

The photographic process used today is essentially the same (though obviously greatly improved!) as that invented by William Henry Fox Talbot in the 1830s. Film emulsion, in the form of silver halide crystals and gelatin is coated on to acetate sheets or rolls. These are exposed in a camera for a very short period of time, where a latent image forms. This contains all the information necessary to produce an image, but requires processing before it can be seen. The development stage amplifies the latent image, and converts the exposed silver halide crystals into metallic silver. The unexposed silver halide crystals are removed during the fixation process, leaving a permanent image. During the development stage, coloured dyes can be formed to produce full colour images, or different developers may be used to produce different effects of graininess or contrast. Black and white or colour negatives need then to be printed on to photographic paper, which undergoes a similar exposure and development routine as the film. Remarkably, in the 150 years or so since Fox Talbot's invention, the process remains very similar, albeit with huge improvements in the speed and quality of the process. Modern photographic emulsions are capable of resolving huge amounts of detail, with extraordinarily good colour fidelity.

These stages of exposure, development and printing are similar to the electronic imaging process. An electronic camera may be used to 'capture' the image, which is stored on a magnetic disk or other medium. The image is loaded into a computer in digital form where it may be processed – the contrast, brightness and colour may be modified, or the image enhanced or manipulated. Finally, the image may be transmitted electronically to another computer, or output to film, paper or other form of hard copy.

Electronic cameras though are only one way in which photographers can use electronic imaging techniques. Conventional 'silver' images can be 'scanned' and the resultant digital information imported into a computer.

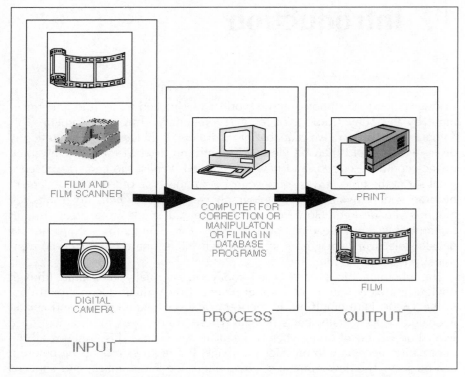

Figure 1.1 *The electronic imaging chain. Images can be imported into computers, either by digitizing analogue images from conventional photography or video sources, or directly from digital cameras. These images need to be stored in digital form. Computers can then perform a number of functions, including data analysis, image enhancement and/or manipulation, and prepare images for pre-press. Output can be in the form of print, film or electronic transmission.*

Many picture archives are currently digitizing their collections for electronic storage and retrieval purposes (see Figure 1.1).

In this book we are going to introduce all areas of electronic imaging to the photographer, from image capture with analogue or digital cameras, to the scanning of silver photographs, to the enhancement and manipulation of images by microcomputer, to their storage and transmission, and final output of those images on to various media. For photographers used to working in darkrooms, much of the technology is very different, with a whole new terminology to learn. Much is derived from the printing industry, and photographers will increasingly become involved in such areas as scanning and producing colour separations, previously carried out by skilled operatives in the printing industry.

Fundamental to the subject is an understanding of computers and their programs – we have assumed no prior knowledge. We have tried to talk

about computing in a non-technical language which we hope photographers can understand. A large glossary is included at the back of the book to help clarify many of the points discussed briefly in the main text.

With today's computers, there is no need to be an expert computer programmer. Computers should be treated as a tool, in the same way as enlargers and processing machines. Operating computers is no more difficult than producing a good professional quality colour print, or retouching it. Choosing the right one is perhaps the most difficult part – advice abounds, much of it conflicting!

Electronic imaging has many advantages over conventional photography. Changes can be made to images before they are printed, thus reducing the cost of paper. Electronic cameras can be used for previewing photographs, removing the need for instant film materials such as Polaroid™, and images can be transmitted rapidly by telephone lines or satellite links. A whole new generation of telecommunications is being installed in many areas of the world, using fibre optic technology, capable of transmitting almost inconceivably large amounts of data. The electronic distribution of these images could become one of the most fundamental changes in the photographic and publishing industries this century.

Electronic cameras can be 'white balanced' to eliminate colour temperature problems, and those images not required can be deleted, to make way for others. Much of the chemical waste generated by 'silver-based' photography can be eliminated. There are disadvantages too – computers and electronic cameras are heavily dependent on batteries. Electronic images take up large amounts of storage space on computer disks, and electronic cameras and computer hardware are currently very expensive.

But the question which any photographer and their client will ask is 'how good are the images?' The answer to that question is not simple, but it is now possible to take electronic pictures, suitable for the front cover of an A4 glossy magazine, which are virtually indistinguishable from film images, using conventional film cameras with electronic backs, and computers costing no more than the price of a good medium format camera and a couple of lenses. Perhaps a better question is 'how much quality do I need for a particular job?' In many instances, newspaper reproduction for example, the quality from digital cameras is more than adequate for successful reproduction.

Photographers and others who deal with images will need to change their working methods if they are to survive in this very rapidly expanding field of technology. The traditional roles of graphic designers, photographers, retouchers and printers are being merged, so that many designers now carry out their own imaging using digital cameras or scanners, whilst photographers increasingly have computers in their studios, capable not only of image processing but also of desktop publishing and of producing colour separations of their images. The traditional skills of the photographer will not change though. Studio photographers will still need to be masters of lighting, and sports photographers experts at exposing at precisely the right time to

capture the peak of the action. It is in the area of image processing, where photographers will increasingly move out of the darkroom, and on to the computer screen and where perhaps the greatest change will occur. In the same way that the publishing and printing industry was revolutionized in the 1980s with the advent of desktop publishing, so image production will change enormously in the 1990s. Digital photography also has great potential to change the traditional methods of distribution and availability of images from the photographer to the image user.

2　Input devices

Comparing apples and oranges

The first question everyone asks about digital cameras is 'how do they compare with film?' The answer is difficult, no common ground of quality exists with which to compare the two systems. Statements such as 'photography quality' usually refer to subjective rather than objective assessment. The problem at the heart of the matter is that conventional photographic methods use analogue or continuous methods of recording images. The digital systems use a digital system of recording data from the image which is compatible with digital based computers (see Figure 2.1).

The numbers game

Film records information at a microscopic level in terms of metallic silver halides. The silver in an image can be considered as a microscopic mountain range corresponding to the tones in the original image. The higher the mountain the more silver and the blacker the tone. In the digital image samples are taken at regular intervals and the result translated into numerical values. The number of samples is called the resolution of the image. The greater the resolution the closer the digital image will resemble its analogue counterpart as is shown in Figure 2.2.

The digital camera system

The roots of digital camera systems began with the development of the portable video camera. The production of small affordable video camera systems was made possible by the introduction of minute printed circuits called Charged Coupled Devices or CCDs. These devices are basically a matrix of light sensitive cells (pixels – short for 'picture elements') on a small computer chip. Pixels are the digital equivalent of film grain – the more pixels in a given area of film, the more detail can be resolved. Most people will be familiar with the solar powered calculator in which the power to the calculator is provided by a solar cell (selenium) window, similar to the selenium cell on a Weston exposure meter. If the light on the cell is insufficient the calculator will not work. If the light is brighter then

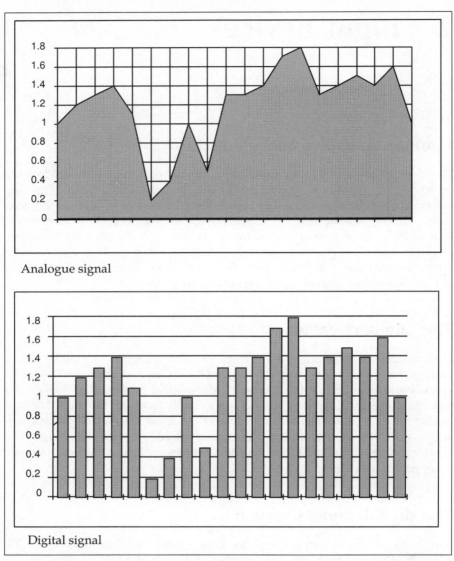

Figure 2.1 *Analogue and digital sampling. The analogue sample records all information but the digital records the same information in terms of discrete samples. The greater the number of samples the closer the signal resembles its analogue counterpart.*

there is enough energy to power the device. Therefore there must be some relationship between the brightness of the light source and the energy produced by the cell. Figure 2.3 shows how three light reactive devices operate.

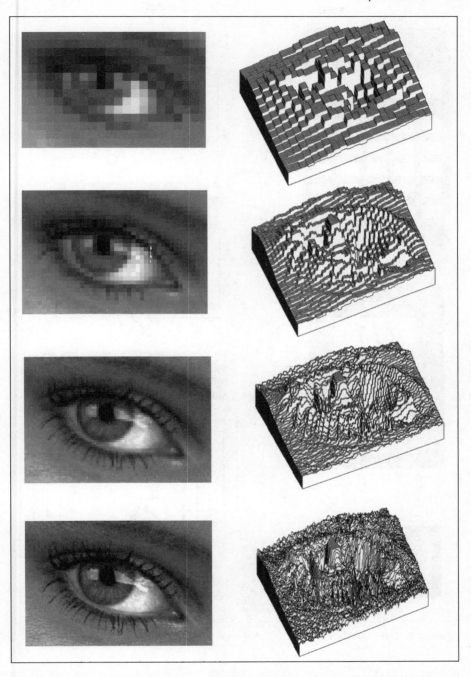

Figure 2.2 *Image resolution. As the number of samples increases the quality of the image improves. As a rough guide photographic film sampled at 2000 samples per inch will capture the majority of the information on film.*

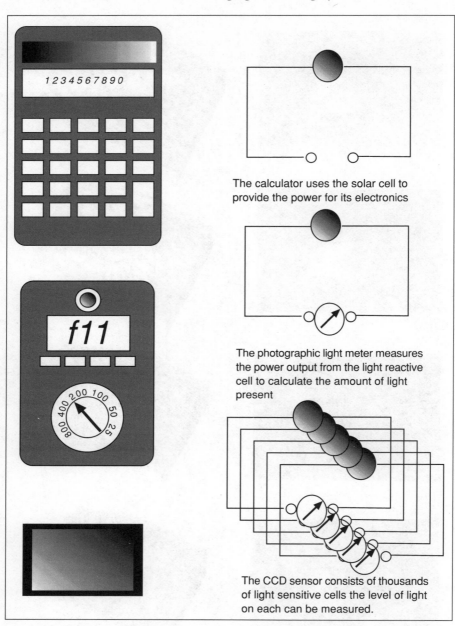

The calculator uses the solar cell to provide the power for its electronics

The photographic light meter measures the power output from the light reactive cell to calculate the amount of light present

The CCD sensor consists of thousands of light sensitive cells the level of light on each can be measured.

Figure 2.3 *Light reactive devices.*

The light sensitive cell

A device more familiar to the photographic industry is the light meter. These use the same principle of light being converted into electrical energy, the output energy being calibrated into a display that is calibrated in f. stops and shutter speeds, relating to the recording properties of film. By miniaturizing the cell or sensor and placing thousands or even millions of them side by side, a CCD chip is created which can record the individual light intensity at any point. All that remains is to replace the film in a camera system with a CCD chip.

CCD the imaging sensor

In understanding the limitations of CCD technology it is necessary to understand the motivation behind its creation. CCDs were invented to solve the problem of miniaturization of video camera systems. Until about ten years ago, the cameras used in television and video were bulky, heavy and fragile due to the glass based tube system inside used to capture the image. The use of image tube technology also meant that they required large amounts of power to work. This heavy power consumption precluded their use by anything but mains power supplies for the majority of situations. The designers of the first CCD video cameras had a very specific brief in mind when they built the first CCD chips: they were designing a chip to record a television signal.

A television picture is created by a number of modulated lines of light written across the screen from left to right, top to bottom in a manner similar to the letters forming words on a page. The quality of the picture increases as the number of lines increases. International standards of how many lines are used vary between different countries. The British standard is termed PAL and uses 625 lines from the top to the bottom of the picture, whilst the American NTSC uses only 525 lines. Television signals also have to display moving images and the illusion is created by sending the first image as a picture on all the odd lines – 1,3,5,7 etc. – and the next image in the sequence on the even lines; the next image in the series replaces the first image on the odd lines and so on. Providing the image is replaced quickly enough, the illusion of a constantly moving image is maintained and the one row misalignment between every other image is imperceptible to the human eye. With the PAL system, the images are replaced 25 times per second.

The technical requirements of producing the video image therefore require the following:

- a method of capturing approximately 310 lines or rows (not all the 625 lines are used for picture information), with an aspect ratio of 3:4, each row consisting of around 400 separate pixels: in total a matrix of 120 000 cells;

- the ability to capture at a rate of 25 images per second;
- the ability to do all this in the smallest possible size.

Domestic television sets are generally viewed from a distance, allowing the circular phosphor dots forming the image to be quite large and to have a sizeable space between them.

Small is not always beautiful

The actual size of the chips used in modern camcorders is about the same as a frame of 110 film (6.6 x 8.8 mm), which has obvious advantages in terms of the overall size of the camera. But the major problem in utilizing such a device in a still camera is the basic lack of information recorded by the CCD due to the relatively small number of sensors and the gaps between them. The small amount of information produced does however lend itself to storage on miniature floppy disks or credit card sized memory devices.

Bigger is better but expensive

The obvious solution to the problem of image quality is to design a purpose built CCD chip for still camera use. This would need a chip with far more sensors on its surface. The failure rate in production of these tiny devices is very high and a non-functioning row or group of pixels renders the chip worthless. Assuming a theoretical failure rate of 25% only three out of every four chips are usable. The practicality of the manufacturing process is that a larger sensor size increases the failure rate and thus makes the chip more expensive to produce. The second problem to rectify is the gaps between adjacent sensors. The creation of square pixels means that the image capture becomes more uniform (Plates 3 and 4). The last consideration is to increase the size of the CCD chip to correspond to the same physical area as 35 mm film, thus allowing the lens used on the system to give the same field of view. Using smaller CCDs mean that only the centre area of the lens is used to capture the image, and this has several effects if the unit is mounted in a conventional camera body:

- it restricts the area viewed in the viewfinder;
- it distorts the centre weighted metering systems;
- the lens focal length is increased, restricting the use of a wide angle lens.

Bigger is better but has problems too!

The use of CCDs with more sensors introduces problems of its own. Larger sensors give larger file sizes (the file size of an image from a typical colour digital camera is about 4.4 Mb) – with the increase in the size of the digital file produced, storage becomes a major issue. The size of the files means an increase in the time taken to store, or download them, which introduces a

delay before the camera is available to take the next picture. This may vary from one or two seconds to a minute or more. In addition the file sizes can be too big to be recorded on floppy disks. The camera must then be connected to an external storage unit or have internal storage capacity. The miniaturization of the hard disk does mean that a unit can be placed inside the camera or used as a removable storage medium.

Power supply to these units is also an issue as the storage medium requires larger amounts of power and the larger image requires more processing. For photographers working on location, large quantities of batteries are required.

Digital camera components

Given the availability of such an image recording CCD sensor, let us examine the components needed to create a digital camera.

1 The CCD chip

This is a matrix of light reactive sensors that will produce an electrical charge proportional to the amount of light which strikes them. This information recorded on the chip needs some method of removal for more permanent storage. The analogy can be drawn to a stadium full of people each having a number on a piece of paper. Being a fully automated stadium, removing the people is achieved by having the seats on a belt system which moves all the seats in the row one step nearer the aisle at a time. The stadium is emptied row by row starting at the top. As each person reaches the aisle they hand their number to an official.

2 Camera body

The CCD must be mounted into a body with a lens which can focus the image on to the chip. This lens system can be either a fixed focal length or a zoom lens. Some manufacturers have adapted existing camera bodies which allow current interchangeable lenses and other accessories to be used. The size of the CCD will have a direct effect on the perceived focal length of the lens. A CCD half the size of the original film will double the focal length. This means that the use of wide angle photography becomes restricted.

3 Analogue to digital converter or interface board

The charge on each sensor is an analogue electrical signal and as such it cannot be read by a computer. Some cameras store the image as an analogue signal, but before it can be read by the computer it must be converted into a digital form. The device which performs this operation is called an analogue to digital converter. This device can either be situated within the camera or

on a separate circuit board placed into the computer. With much smaller video cameras the image is recorded on to floppy disk as an analogue signal, which has the capability of being viewed on a domestic television set.

4 Storage medium

Assuming that we wish to take more than one image, a suitable storage medium must be provided for the digital files. The form this device takes is dictated by the size of the images. For smaller files removable floppy disks or memory cards are sufficient but as the file sizes increase a disk drive is needed. Figure 2.4 illustrates the pathway from CCD to storage unit.

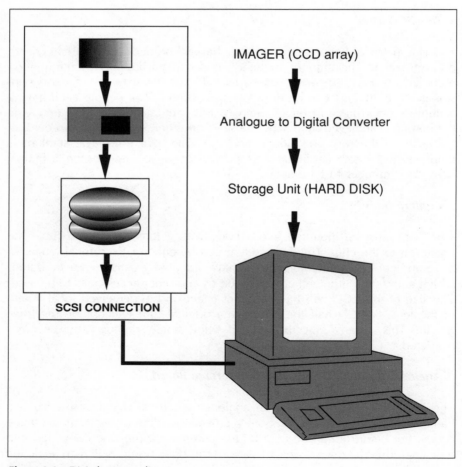

Figure 2.4 *Digital camera diagram.*

Colour recording

The design of the CCD chip dictates that the device only records images in tones of grey. With silver-based colour film the image is recorded in several colour sensitive layers. This is possible as each layer is transparent. The CCD chip is a single opaque layer. To add the dimension of colour a number of options are available.

1 The use of three CCD chips

Three CCDs could be mounted inside the camera. The camera would require a beam-splitting prism system and colour filters behind the lens to separate the image into three signal elements of red, green and blue. The three signals produced would then need to be integrated back into a single signal within the computer.

2 Filtering colour on the CCD

The individual sensors can be divided up in response using a mosaic of red, blue and green filters built into the surface of the chip (very similar to the way the Lumiére brothers produced colour photographs called Autochromes in the early 1900s by adding coloured transparent red, green and blue starch

G	B	R	G	B	R
R	G	B	R	G	B
G	B	R	G	B	R
R	G	B	R	G	B

Figure 2.5 *CCD filtering system. The CCD is divided into groups or clusters of three cells. The cells in each group have a green, blue or red filter over the cell. Therefore each group can determine the colour in terms of the three colours for its own cluster. Key: R = red filter, B = blue filter, G = green filter.*

grains to their emulsions). This process, however, means that although all the sensors on the surface of the chip record light, each subgroup of three different sensors decide on the colour of their group. The camera software knows the filter value of each of the three colours so it can determine the correct weighting to apply, and thus give the correct colour response (Figure 2.5).

The concepts in practice

The still video camera

At the bottom of the price range the still video camera systems use a standard video CCD in place of film. The output signal is read and stored in analogue form on 50 mm floppy disks. The signals on the disks can be translated into digital signals via a digitizer board in a computer. The resolution/quality of the image is low in comparison with film. In terms of information the chips used have 380 000–600 000 pixels. Still video cameras use 50 mm floppy disks to record either 50 fields or 25 full frame images. Like audio tape, the signal can be erased, and new images recorded on top. Though not ideal as a still frame capture device, cameras utilizing this technology can be produced relatively cheaply and, provided that the limitations of the size of the final print or reproduction is kept small, can deliver usable images. A number of still video cameras went with the American armed forces to the Gulf War, to capture images which were transmitted immediately to the Pentagon in Washington. In the UK, estate agents use them to produce instant sales pictures of houses, and police forces for producing scene of crime pictures. Examples are included on the enclosed CD.

The digital camera

These units are self-contained, and use replacement backs containing the CCD chip attached to unmodified cameras such as 35 mm or medium format SLRs. The image produced is converted immediately into digital form, which is then stored either internally on a hard disk within the camera, or sent to an external storage device containing a hard disk. These cameras have a higher quality purpose-built CCD sensor with 1 500 000 pixels, giving better quality images (Plates 5–10). The cameras are available either as monochrome or colour versions, and have a range of 'effective' ISO speeds, from 100–800 ISO. Because the chips used at present are smaller than film, the focal length of the lens becomes a problem. The standard focal length for any format is obtained from the length of the diagonal of the format used. Thus, for a 35 mm format, the 'standard' length used is 50 mm. With a much smaller imaging surface the 'standard' lens becomes much less, around 24–28 mm. Whilst this is excellent for many sports photographers, it becomes a major problem for photojournalists used to using wide angle lenses. The ideal

solution would be to produce the CCD the same size as the 35 mm format, which will solve the problems of focal length, metering and viewfinder image size. However, increasing the CCD's size increases the failure rate in manufacture and thus increases the cost of the unit.

Some of the external storage units have keyboards for captioning pictures, and facilities for transmitting the images via telephone lines.

Three pass or sequential filtration system

Designed for studio still life situations these units take three black and white images in turn, one each through a red, green and blue filter. Each image is recorded by a CCD matrix. They can be either a purpose built unit or a separate back which fits on standard film cameras (Plates 11–14).

Scanning systems

This is a system designed as a 'film back' for existing camera systems. A different exposure system is used by 'scan back cameras' where the three separate images are still exposed sequentially but each image is recorded on a single row of CCDs which travels across the image area in much the same way that prints and transparencies are scanned in desk top scanners (discussed in Chapter 3). The quality of the images produced by these systems is excellent, but they are confined to studio still life use, as the capture time is anything from 90 seconds to 12 minutes depending on the speed that the row of recording CCDs takes to cover the entire image area. The size of files which they yield is large, up to 72 Mb.

The CCD advantage

For the scientific and technical user, CCDs offer many advantages over conventional film, albeit with several disadvantages as well. Most types are sensitive to infrared, being used in satellites, for example, for producing multi-spectral images of the earth. They are also inherently sensitive to long wave ultraviolet light, though most are manufactured with a glass filter cemented to the front of the chip to absorb it. Many manufacturers offer the option of making the CCD without the filter, thus giving many photographers, such as those working in medicine, a useful ultraviolet sensitive camera.

CCDs also react to very brief bursts of light, making them suitable for high speed short duration photography. Due to the problems of delay with mechanical shutters, much of this type of work is done using an 'open flash technique', locking the camera shutter open and triggering the flash. If the shutter in front of a CCD is held open for more than a few seconds, 'noise' will be seen in the image due to the dark current generated. This can be filtered from the image quite successfully using one of the 'noise' filters in programs such as Photoshop.

3 Scanners

Desktop flatbed scanners

The cheapest and most widely available form of scanner technology is the flatbed scanner. Primarily designed to digitize line drawings or text for optical character recognition (OCR), prices for these units start from a few hundred pounds. The scanner has two modes of operation.

Line art/monotone mode

This is a representation of an image which consists only of black or white with no grey tones. The record of this image therefore needs only to identify the presence of a line or its absence: a binary function. This is the easiest medium to scan as the only parameter which needs to be decided is the threshold (grey tone) which records as black (just like giving line or lith film the minimum exposure for a black). The information is recorded as computer data with each bit of information representing a single tiny image sample called a pixel. In photographic terms this would be the equivalent of exposing an image with Lith Film.

Photographic mode

Greyscale

The particular shade of grey at any point is termed the *reflective density* or *transmission density*. The difference being that transmission density is a transmitted measurement for film and reflective density a measurement of the light reflected from a print original. These densities are measured, and in conjunction with established thresholds converted into computer binary data. Each sample is normally given eight bytes in which to record its tonal value; this translates into 256 tones of grey from white to black.

Colour

For systems operating in colour three scans are made and a reading is stored of the amount of red, green and blue in each pixel measured. The resulting file requires three times the information of a greyscale image. Additional software built into some scanners can convert this into a CMYK file, cyan, magenta, yellow and black, the four inks used by the printing industry for most colour printing.

The flatbed scanner

The flatbed scanner reader unit has a light source and a recording unit. This recording unit is based on CCD technology and can be either a single linear array of CCDs the width of the scanner's operating plate or a block of CCDs. The larger the number of CCDs, the faster the operation. This unit is mounted on a moving element which transports the light and recorder in small steps between each scan. The scanner light reflects off the original as the light moves across it and the recorder detects variations in light reflected from the grey tones in the original. In operation the scanner starts in the home position at the upper right-hand corner of the scanner glass. Since the original is placed face down, the home position corresponds to the upper left-hand corner of the original. Therefore from the point of view of the scanner, it

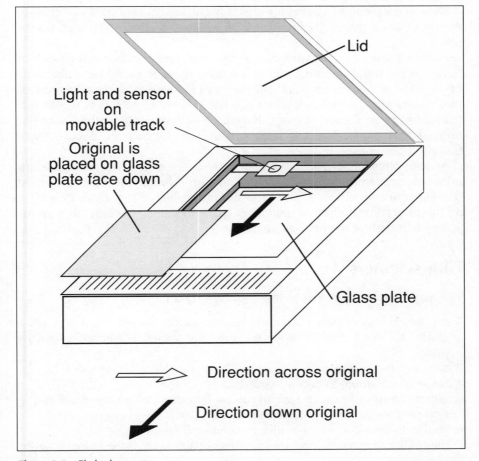

Figure 3.1 *Flatbed scanner.*

scans the first line from left to right across the original, or in the case of a row of CCDs scans each line at a time. It then moves down the original and scans the next line. This process is continued until a complete image of the original is built up and then the scanning head returns. Some flatbed scanners can make measurement samples at a variety of rates by altering the distance between samples. The sampling rate is chosen by the operator to match the size of output. As an example: if a linear array of CCDs were 20 mm wide and had 200 elements the sampling rate would be 10 samples per millimetre. The array would then move down the image 0.1 mm and scan the next row. However, if after the first row were scanned, the array moved across the image by only 0.05 mm and a second scan were recorded, the two recordings could be interlaced to give an effective sampling rate of 20 samples per millimetre. To maintain the height to width ratio the CCD array is moved down the image by 0.05 mm and another two scans read by the CCD array. A flatbed scanner and its method of operation is illustrated in Figure 3.1.

Note that scanning systems for digital backs for conventional cameras use the principle of the single line of CCDs which scan the image area line by line.

A flatbed scanner is capable of scanning transparent material such as film. However the usual sampling rate of a flatbed scanner would be in the range of 75–300 samples per inch and although this is suited to, and can give excellent results from, a 10″ x 8″ print the result from 35 mm film would lack resolution. Some flatbed scanners have an adjustable optic path to scan film originals but the best results from smaller film formats are obtained with purpose built units.

As with other photographic procedures it is essential to keep all glass and print or transparency surfaces clean and dust free for the best results. All scanner software allows you to crop the image before scanning. Be sure to do this as scanning white or redundant space (non-image areas) takes up just as much computer memory as image!

Film scanners

The major advantages of scanning film directly are:

1 no optical loss of data from an enlarging optical system;
2 ability to input directly from transparency material without expensive prints;
3 speed in the process;
4 minimal darkroom facilities needed;
5 either colour or black and white can be produced from colour negative or transparency;
6 facility to preview negative film as positive images;
7 the ability to magnify and examine the image on a large colour monitor before use.

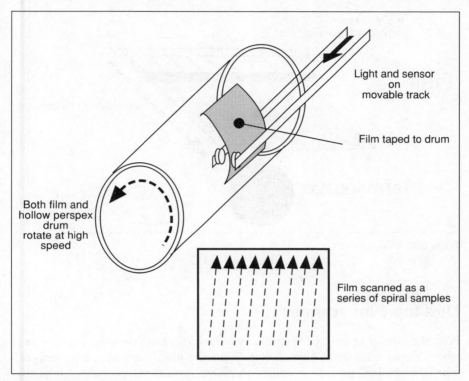

Figure 3.2 *Drum scanner.*

Traditional drum scanning

Scanning of film originals was traditionally carried out with a drum scanner (Figure 3.2). On this system the film original was secured to a hollow Perspex drum which was rotated at high speed. A light source then travels across the film inside the spinning drum and the light transmitted by the film measured by a PMT (Photo Multiplier Tube) detector on the outside of the drum. The PMT technology is more sensitive than its CCD counterpart and thus is better at picking up colour detail in dark areas of the image. Also PMT scanners record images in terms of their RGB values which the scanner's computer element automatically converts into CMYK components ready for photomechanical printing purposes. The calibration and operation of traditional drum scanning systems requires trained operators to ensure correct colour and tonal reproduction. The major advantage of the majority of drum scanner systems is that they are operated in the environment of a repro. house and therefore can be calibrated exactly to the parameters of the printing press from which the image will finally appear.

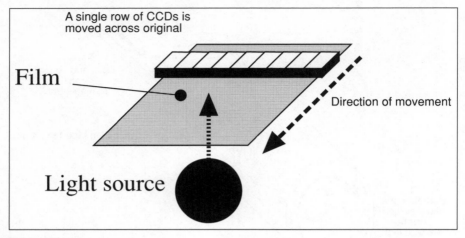

Figure 3.3 *Linear array.*

Desktop film scanner

With the advent of the CCD sensor, manufacturers built desktop scanner units which could scan small format film. Typically these units will scan only 35 mm. The method used to produce an image on a desktop scanner uses one of two methods, a linear or a block sensor.

Linear sensor

In a linear sensor system a single row of CCD sensors is moved across the surface of the film using a stepper motor (Figure 3.3). The physical resolution is dependent on the number of cells in the array and the accuracy of the motor. The colour information is recorded either by a three pass system once for each of red, green and blue elements of each pixel or by a filter coating on the CCD surface to record colour in a single pass. Physical resolution is increased by reducing the distance moved by the stepper motors between samples.

Block sensor

In the block sensor system three consecutive images are captured using red, green and blue light (Figure 3.4). Although generally more expensive this system produces much better results and is quicker than the linear sensor method. Physical resolution can be increased by means of altering the optical path that the sensors uses to view the image. If the sensor takes a single recording of the entire image the resolution can be doubled by moving the

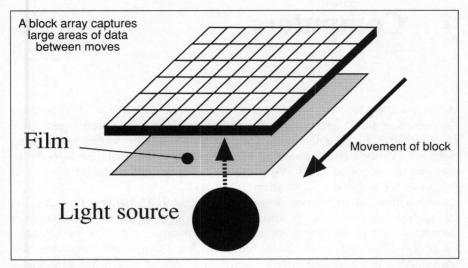

A block array captures large areas of data between moves

Film

Light source

Movement of block

Figure 3.4 *Block array.*

optics and recording the image in four samples, one for each quarter of the image which will effectively double the resolution of the final image file.

Both of these film scanner systems have found great favour in the newspaper world where photographers routinely process colour negative film, and then scan an image into a portable computer and transmit the file to their editors within minutes of an event happening.

4 Computers

When small desktop microcomputers first became widely available, perhaps 10 years ago, they were slow, had small memories and required a great deal of knowledge to operate them. They were not ideally suited for imaging purposes. Various commands had to be typed into the machine in order to perform the required tasks. Very often, the users had to write their own programs for a specific application.

Within the last five years or so this situation has changed dramatically. Computers have become 'user-friendly' and much cheaper. No longer is it necessary to type in strings of commands. Instead, most computers have Graphical User Interfaces (GUIs) whereby the majority of operations are controlled with a pointing device known as a 'mouse' which moves a cursor around the screen. Many of the computer functions are shown as symbols (icons). With modern computers, the display on the screen is analogous to that of an office, with a desktop, stores of files and a wastepaper basket. Files (collections of named data or images) are retrieved from their storage place (hard disk, floppy disk or external disk), and brought on to the desktop screen to be viewed or worked upon. A click switch on the mouse is used to move or access items, and menus on the screen give the user a range of command options. Files are deleted by dragging them into the wastebasket and emptying it. The Apple Macintosh computer has become very popular, almost a cult, with artists, designers and photographers as it is extremely easy to use. It was originally designed so that a small child could operate it, without any knowledge of computers at all. Recently, the PC type of computer has also adopted the GUI approach of the Apple with its Windows software, and many imaging and desktop publishing programs, previously only available for Apple computers are now available for PCs as well. (Note: the term PC will be used throughout to describe IBM compatible computers.) Many companies and other institutions, particularly in the UK are PC based, and it would not make sense to introduce a new computer system into the institution, although Apples and PCs can be easily connected together on networking systems, such as Ethernet, for the sharing and transference of files. However, for many people with little or no computer experience, the Apple is recognized as being the easiest and 'friendliest' of computers to learn. On the other hand, the PC is often regarded as being the most adaptable and easiest to customize.

As to the question of which is the best machine for electronic imaging applications, there is no simple answer. Many different machines costing a range of prices will perform many of the tasks required by photographers, albeit at different speeds. Before investing in a system, photographers must ask themselves several questions, as discussed in the next five sections.

What type and quality of output will be required?

Whilst it is possible to print directly from digital files, many photographers will still need to output on to film for many purposes. If this is to be high resolution 10" x 8" transparency, a specifically designed imaging workstation is probably the best answer, but these are very expensive. Much controversy exists regarding the size of files required to give sufficient quality for such purposes. Output to 5" x 4" and smaller film, or thermal print, can be achieved quite easily on a desktop computer, though it will invariably need to be equipped with a large amount of RAM.

What software is available?

Some packages are specific to particular computer platforms.

What other types of work will the computer have to carry out?

Will the machine be required to carry out other work, such as multimedia applications, hold large amounts of information in a database, or perform maths-intensive work in complex spreadsheets? Will the computer be required to run more than one application program at the same time, and swap data between them?

How readily can the machine be upgraded?

Is it capable of being upgraded with the latest processors (such as PowerPC and Pentium chips), and software, or being fitted with extra circuit boards such as frame-grabbers, graphics cards to give 24 bit colour, and accelerator cards? How much memory can be fitted?

How large is the budget?

This is obviously a major consideration for most people. Over the last couple of years, prices of desktop computers have fallen dramatically, but even so, computers for imaging have special requirements of memory and speed which make them relatively expensive. Remember to cost all of the extra items required for imaging purposes, such as external storage, CD-ROM drives for PhotoCD, SCSI connectors and Ethernet cards if these are not included in the price of the machine.

In this chapter, we will consider some of the basic operations of computers and their application in imaging, and will make some broad generalizations as to the type and size of machine most useful. This is not a computer book, and more detailed descriptions about the various machines will be found elsewhere. We will concentrate on the two commonest platforms as far as

general photographers are concerned, the Apple Macintosh, and the IBM PC. Rather than try to make direct comparisons between the two systems we will look at the characteristics of each type separately, and compare them where appropriate. Other types of computer, such as the Amiga, are capable of being used for imaging and many of the remarks made here will be applicable to them. Others, such as Sun Sparc, Silicon Graphics, Barco Personal Creator™, Dicomed Imaginator™, Crosfield Mamba™, Kodak Premiere™ and Quantel, are examples of 'high end' systems, and are beyond the scope of this book. They are generally very expensive although within the last couple of years prices have dropped greatly. The main difference between a desktop computer and a 'high-end' system is the ability to work with very large images (perhaps 300 Mb) and work in real time. The principles of their operation are very similar to the smaller systems. The speed of development of computers at present means that by the time this book is published, any specific models mentioned will have been superseded, so we have tried to discuss them in general terms. Also, new processing chips and operating systems are constantly being developed which will mean that future computers will be able to perform more complex tasks to larger images at much faster rates.

When buying a computer system, we would strongly recommend that you see the machine in action, and running the *actual* programs that you will be using, on the *actual* monitor you are considering. Very often, different programs run at particular speeds irrespective of the processing chip in the computer. Magazines often publish speed tests in order to compare one computer or piece of software against another. These must be treated with caution, as there are very many variables, and often, when one machine performs one type of operation very quickly, it may not do so with another. It is essential too that the program is installed on the computer correctly, so that the memory allocation is optimized to give the best performance. If you intend using a computer for specific applications, then try to get your dealer to let you try it out. Try to perform the same set of operations, such as rotating the image through a specified number of degrees, or apply a certain filter to the same image, to compare speeds of operation.

Bits and bytes

Before discussing the various components of a computer, and differences between various systems, it is necessary to understand some fundamental concepts and terminology of computers, how they work, and how information is stored.

Strictly speaking, microcomputers should be called digital computers, because they can only manipulate digital data. In fact this digital data must be in the form of binary signals, with only two possible values, on or off, pulse or no-pulse, just like an electrical switch. One item of digital data, represented by a 1 or a 0 is called a *bit* (short for binary digit). Two bits can

give four instructions (i.e. 0 and 1 can be configured in 4 different ways: 00, 11, 10 and 01). A group of eight bits, or switches gives 256 (2^8 = 256) possible combinations of 0s and 1s , and represent single letters, or other characters for example. This is called a *byte*. Eight bits is sufficient for all of the upper and lower case characters and other symbols required on a standard keyboard. 24 bits give 16.7 million combinations.

Originally, most personal computers using 286 processors for example were 16 bit machines, meaning that they could handle 2^{16} (65 536) bits at a time. Nowadays, PCs with 386 and 486 processors, and all Macintoshes are 32 bit processors, and can handle 2^{32} (4 294 967 296) bits at a time.

Terminology
8 bits = 1 byte
1024 bytes = 1 kilobyte (K)
1024 kilobytes = 1 megabyte (Mb)
1024 megabytes = 1 gigabyte (Gb)

[Strictly the term 'kilo' refers to 1000, but because we are dealing with a binary system, the numbers operate in a doubling fashion: 2, 4, 8, 16, 32, 64, 128, 256, 512, 1024].

The hardware

This term refers to the actual components of the computer system, which is generally divided into three main areas, the processor, the monitor display, and the keyboard and mouse. Many peripheral devices can be connected to computers, such as external storage devices, CD-ROM drives, scanners, graphics tablets and printers.

The main requirements for any photographic computer imaging system are large amounts of memory (RAM), large amounts of storage space, speed of processing the data and high resolution of monitor display.

The processor

The computer is controlled by a microprocessor, or 'chip', the type of which often gives rise to the generic type of computer (e.g. 286, 386, 486 in PCs). The higher the processor number, the more elements are available for communication, and therefore the more powerful it is. The processor runs at a fixed clock speed, which is the speed at which the Central Processing Unit (CPU) communicates with the various elements within the computer. The speed is rated in megahertz (MHz) – one megahertz representing one million instructions per second. It is not, however, sufficient just to compare clock

speed of chips however, as modern chips, with integrated co-processors and memory, may run faster than older chips. For example, a modern Macintosh computer, running at 25 MHz actually performs some tasks more than twice as fast as an older 40 MHz chip. For imaging purposes, speed is a critical consideration when selecting a machine. Various methods of accelerating certain processes are available and will be discussed later.

The central microprocessor can be accompanied by other devices such as a 'maths co-processor' (or 'floating point co-processor' or FPU), which helps speed up applications requiring large amounts of mathematical computations such as graphics or complicated spreadsheets. Motorola 68040 processors, used in Apple Macintosh computers, and several Intel 486 processors used in PCs have built-in maths co-processors.

Operating systems

The operating system of a computer is a series of computer programs which enable other programs to run on the computer. It creates an environment enabling different programs to perform functions such as saving, displaying lists of stored files and deleting. Without an operating system, each program would need to have these functions built-in. IBM clones use 'MS-DOS' (Microsoft Disk Operating System) whilst Apple Macintosh computers currently use 'System 7'. Many new operating systems are under development including 'Windows 95'. Most PC users also run their programs under Microsoft Windows (many programs will only run under Windows). This is really a collection of programs enabling the user to perform many tasks on the computer more quickly and easily than under DOS, which requires the typing-in of commands to instruct the computer to perform operations.

A criticism often levelled at PCs is the protocol for naming files. With Apple Macintosh computers, you can give an image a descriptive title, up to 31 characters in length (e.g. Seagull on nest with young). Information about the file type is stored internally within the file. With MS-DOS, the computer recognizes the file type from a three letter extension included as part of the file name. This file name is divided into two parts, the file name, which can only be up to eight characters long, followed by the three character extension. The file name is separated from the file type by a full stop (period) e.g. Seagull.TIF, Building.EPS. The first is a TIFF file, the second an Encapsulated PostScript file. This problem has however virtually been eradicated with many modern Windows applications.

Apple Macintosh computers

Macintosh computers use microprocessors from Motorola, the 68000 series. Only those using the 68040 chip, running preferably at 33 or 40 MHz, or

the new generation of PowerPC chips should really be considered for serious imaging purposes. As mentioned previously, the Macintosh computer was designed specifically for ease of use. The mouse controls many operations such as opening documents, saving changes and copying documents. It is now 10 years old and revolutionized the publishing industry in the 1980s with the advent of desktop publishing programs such as PageMaker™ and QuarkXpress™, and the ability to change typefaces to virtually any style or size. Nowadays, multimedia versions are available with video framegrabbers and sound cards for stereo output, built in CD-ROM drives and video editing programs which could well make traditional video edit suites redundant over the next few years.

IBM PC computers

IBM PC compatible computers use Intel processors, usually the 386 or 486. For imaging purposes the 486 is really the only one to be considered. It is available in several versions, including the SX, DX and DX/2. The SX is cheaper, but some types communicate with the RAM at only 16 bits a time, whereas the DX series are 32 bit processors. We would recommend most strongly that the 486DX or DX/2 processor running at 50 or 66 MHz, or the new generation of Pentium 586 chips are best for imaging purposes.

Because PCs are much commoner than Apples in business and domestic applications, there is a huge range of accessories, upgrades and add-ons available for them, making it possible to customize the PC to a very precise specification.

RAM (Random Access Memory)

Programs and other data are stored on disks, usually the internal hard disk of the computer. Before the computer can carry out any functions, the program must be transferred into RAM, together with the data required to be viewed or manipulated. Perhaps a better term for RAM is Read Write Memory, in the form of chips. RAM is temporary storage – when the computer is switched off, everything stored in RAM is lost. Anything that you wish to keep must therefore be saved either to the hard disk or other form of storage such as a floppy disk.

In general the larger the effective RAM, the more easily tasks such as image manipulation can be carried out. The operating system software also (DOS, Windows, System 7, etc.) will require its own allocation of RAM: typically, DOS requires 2 Mb RAM on a PC, with Windows requiring an extra 4–6 Mb, whilst System 7 on a Macintosh needs at least 2 Mb to run. An imaging program like Adobe Photoshop requires at least 3 Mb RAM (preferably 5 Mb). Therefore, before an image has even been opened, we have used up at least 5 Mb of RAM. The images themselves will be large, anywhere probably from 500 Kb to several Mb. As a general rule, an image requires three times as

much free RAM as it is large (this is because the program maintains a record of the image prior to manipulation to enable that operation to be 'undone'. In some cases it also reserves another block of memory to enable it to carry out sophisticated operations). Thus a 1 Mb image (this would only be low quality colour) needs 3 Mb RAM. This makes a total of 9 Mb RAM, and this really is a minimum figure. We would recommend most strongly that for serious imaging purposes, 16 Mb RAM is the minimum required, but preferably a figure of 24 Mb or more. As new programs become available, the amount of memory they require seems to increase!

When buying a machine it is essential to check that the machine can be upgraded to the amount required. It is a relatively easy job to upgrade (increase) the RAM of the computer yourself by inserting extra memory chips – SIMMS ('Single In-Line Memory Modules') into slots on the main circuit board, though beware – many manufacturers say that doing this yourself will invalidate the guarantee.

One way of increasing the amount of memory available to open and manipulate images with a Macintosh is to make use of the Virtual Memory facility of System 7. This allows part of the hard disk memory (or another disk assigned as the 'scratch disk') to be used as RAM, so that very large images can be opened, even with relatively small amounts of RAM. However, this operation slows down the computer greatly, and is not to be recommended unless absolutely essential. With PCs, a similar system operates, where a part of the hard disk is allocated as a 'swap file'.

Monitors

Important considerations for imaging are the size of the monitor, the number of colours which can be displayed on a monitor, and the sharpness of the image. When running imaging programs such as Adobe Photoshop, a minimum of 16 bits (32 768 colours) per pixel ('bit depth') is required, and preferably 24 bit (16.7 million colours) to give photographic quality images. (The 'bit depth' of an image refers to the number of grey shades, or colours which a monitor can display. An 8 bit system can display 2^8 greys or colours, which is 256. A 16 bit system can display 2^{16} colours (32 000) whilst a 24 bit system can display 2^{24} colours or 16.7 million.) The correct combination of computer, monitor and graphics card is required to give this facility, and it must be checked carefully when selecting a machine. With some Apple models for example, extra VRAM (Video RAM) chips can be added to give the required bit depth with some monitors. It is easy to calculate the amount of VRAM required for specific bit depth for certain monitor sizes from the formula:

VRAM required = bit depth x (horizontal resolution x vertical resolution)

A 14" monitor, with a resolution of 640 x 480 pixels, displaying just black or white, requires 307 200 bits of information, or 38 400 bytes (bits divided

by 8 to give bytes) or 37.5 kilobytes (38 400 divided by 1024 to give kilobytes). To achieve 8 bit colour (256 colours or greys) this monitor will require 37.5 x 8 = 300 k. Therefore, a computer with 512k of VRAM fitted as standard is capable of displaying 8 bit.

To achieve 16 bit (32 000 colours) requires 37.5 x 16 = 600k.

To achieve 24 bit (16.7 million colours) requires 37.5 x 24 = 900k.

With other monitors, graphics cards will be required. Different computers will require different cards, and advice should be sought from the dealer for each specific machine.

Monitor resolutions are quoted in pixels (e.g. 640 horizontally x 480 vertically). A single pixel is created by several adjoining points of light on the display. The fewer the dots of light used to create the pixel, the better the resolution.

Some typical monitor resolutions

VGA	640 x 480
Super VGA	800 x 600
Macintosh 16" colour display	832 x 624 pixels

The size of a monitor is quoted in inches, and is measured diagonally from corner to corner. This may be misleading however, as this figure will probably not be the actual image size, and manufacturers seem to use different criteria for measurement! A 19' monitor is 11½" x 15¼" (292 x 388 mm), but only has an image area of 10¾" x 13⅝" (273 x 344 mm). It is easy to calculate the usable image area of a screen, knowing the vertical and horizontal pixel count, and the screen resolution. In the example above:

19" screen (483 mm):
horizontal pixel resolution of 1024 pixels
vertical pixel resolution 808
resolution 75 dots per inch

This gives an image area of 10¾" x 13⅝" (273 x 344 mm).

Other specifications to examine when choosing a display monitor are the vertical scan rate (or screen refresh rate) and dot pitch.

Vertical scan rate

Television pictures are transmitted as interlaced signals. The electron beam first scans the screen once, to give half of the picture or field, then does so again, the second scan interlacing with the first to give a complete picture, or frame. This is known as the vertical scan rate. In the UK, the PAL system

of television is used, working at 50 Hz – the screen is 'redrawn' 50 times per second. However, with interlacing, only half of the image is redrawn at each pass, so that we end up with a framing rate of 25 frames per second. Computer monitors work at figures between 50 and 80 Hz, and are generally non-interlaced, so that the screen is redrawn at a rate of between 50 and 80 frames per second – i.e. each pixel is scanned at this rate. If the rate were too low, a flicker effect would result which, as we generally sit quite close to computer monitors, would become very uncomfortable to look at after a time. The image on a computer monitor is therefore much more stable than a domestic television. Generally, a scan rate of 70 Hz and over guarantees a flicker free display.

Dot pitch

Dot pitch refers to the distance between the holes on the shadow mask, a thin metal plate with holes through which the electron beams pass before striking the phosphor coated inside the face of the cathode ray tube. Good screen displays have a small dot pitch (e.g. 0.26 mm), high dot pitches give coarse, grainy images. In Sony Trinitron™ based monitors (which tend to give sharper and brighter images than those with a shadow mask), the shadow mask is replaced by an aperture grille made of thin parallel wires. The specification in this system is referred to as a 'stripe pitch' rather than dot pitch.

Whilst any size of high resolution monitor, capable of displaying 16 or 24 bits per pixel is acceptable for imaging purposes, a reasonably large one is to be recommended, 16" or 19" are excellent. This allows an image to be displayed along with other windows for showing paint and brush palettes and perhaps the 'curves' window as well. At times you will probably also want to display several images at the same time – the larger the monitor, the more information it can display.

Mice and graphics tablets

The pointing device known as a 'mouse' often supplied with computers, is fine for most purposes, but not very good for drawing precise outlines and other imaging applications. Several alternatives using larger balls called Trackballs are available and are more easily controlled. An alternative to the mouse concept is the digitizer or graphics tablet, a flat plate, usually A5 or A4 in size. Drawing and pointing is carried out with a stylus which looks and acts very much like a pen. Much finer control over drawing, or making selections is possible with the stylus, which is usually pressure sensitive. When painting in programs such as Letraset's Painter™ or Adobe Photoshop™ when more pressure is applied to the stylus, more 'paint' is applied. Unlike the mouse, which can be raised and moved to another part of the mat without altering the position of the cursor on the screen, the positioning of the stylus on the tablet dictates the position of the cursor.

Digitizer (frame grabber) board

If the image required is to be obtained from a video or still video source, then, as discussed in Chapter 1, it needs to be digitized. Several 'frame-grabber' boards are available from a variety of suppliers, for both PCs and Apple computers, for converting an analogue video signal into a still digital one. Various examples are available including those from Neotech, Kingfisher and Screen Machine. Depending on the board, they will generally take a variety of input signals, e.g. Composite video, SVHS, etc. and convert it into a still frame. Many newspapers regularly 'grab' individual frames from transmitted television pictures with a frame-grabber board. For multimedia applications, boards are also available for digitizing moving video sequences. An example is the Video Spigot board for the Macintosh.

Connecting other devices to the computer

When connecting devices such as scanners, external disk drives and printers to computers, the information needs to be sent quickly through the cable system used. On IBM clones, there are two types of socket, or 'port' used, serial and parallel ports.

The serial port on a PC is an industry standard, the RS-232 port, though even with this standard, the variety of connectors can be confusing. It is a multi-purpose port for connecting mice, modems and other devices to the computer. The basic principle of the serial port is to have one line to send data, another to receive data, and several others to regulate the flow of that data. The data are sent in series, i.e. one bit at a time. This is somewhat inefficient, but no problem for communicating with device like mice, which do not require speed, and for modems connected to standard telephone lines which can only handle one signal at a time.

The parallel port is often referred to as the Centronics port. It is used most often for connecting printers. The parallel port has eight parallel wires which send eight bits of information simultaneously, in the same amount of time which it takes the serial port to send one. One drawback with the system is that of 'crosstalk' where voltages leak from one line to another, causing interference of the signal. For this reason, the length of parallel cables is limited to approximately 10 feet (3 metres). Most PCs have both serial and parallel ports. The Macintosh computer generally has one or two serial ports, one for the printer, one for a modem and another called a SCSI connection.

SCSI connections

Small Computer Systems Interface. The SCSI (pronounced 'Scuzzy') connection permits high speed communication between the computer and peripheral device, such as a scanner, external hard disk, CD ROM drive or even a digital camera.

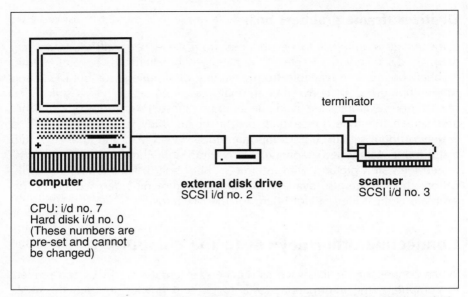

Figure 4.1 *Example of an SCSI chain, showing an external disk drive and scanner attached to a micro-computer. It is essential that each peripheral device has its own identity number, and that the last device in the chain is fitted with a terminator. Some devices have built-in terminators, so check with the instructions for that device before attaching it. Always turn on the SCSI devices before starting the computer, otherwise the computer cannot recognize the SCSI devices.*

Up to six extra SCSI devices can be connected to the computer. They are linked, or daisy-chained together, with each device being assigned a specific identity number. This ID number can be set on each device using switches on the back. By convention, the internal hard disk of the CPU is ID no. 0, and the computer itself is no. 7, which means that six other devices can be connected. SCSI is a form of 'bus' – a common pathway for the relaying of data, shared by several devices. A terminator (terminating resistor) must be used at the start and end of the chain to identify the limits of the bus and prevent signals reflecting back on the bus after reaching the last device (Figure 4.1).

The SCSI bus on a Macintosh Quadra can send 5 million characters (5 Mb) per second. It does this by sending the information in the form of 8 bits in parallel mode. When using SCSI devices, always ensure that the devices are switched on before the computer. Generic software, such as 'SCSI Probe', is available, often through shareware and public domain software suppliers, enabling you to check that all SCSI devices in a chain are connected ('mounted') properly.

The majority of the IBM PC machines lack SCSI connection, although the facility can be added by using a SCSI card which is fitted inside the computer.

Problems may arise in fitting these cards to portable computers if for no other reason than lack of space inside the case.

Accelerator boards

A major problem found when using desktop computers for image manipulation is that of speed. Even with the fastest possible processor, many operations such as applying filters, or rotating the image, can take an appreciable amount of time to carry out. Many companies manufacture accelerator boards, often specifically designed to work with applications like Adobe Photoshop. These may contain Digital Signal Processors (DSPs) which help speed up mathematically intensive operations. DSPs are now being built into some new computers, although they may have no effect until software is written to take advantage of the facility. Accelerators can speed up many operations by as much as 2300 per cent! They are expensive, but if the computer is to be used primarily for dealing with large images, they are well worth considering.

Future developments in computing

Developments in the computing world over the next couple of years will mean that Apple Macintosh and IBM clones will move closer together. Talks between Apple, IBM and Motorola have led to the development of PowerPC™, a new generation of microprocessors which will perform operations much faster than existing chips, and allow MS-DOS and Windows users to run all their programs on Macintosh computers. These new PowerPC 601 and 603 RISC-based (Reduced Instruction Set Computer) processors enable the CPU to process instructions very efficiently, by using independent execution units to handle multiple instructions simultaneously. Existing 68040 processors use CISC (Complex Instruction Set Computer) architecture which sends instructions through different units one at a time. These new processors became available in early 1994, and it is planned for several others to follow. Apple Macintosh computers can now run MS-DOS and Windows applications as well as all the existing Apple software. In many instances, the two systems operate seamlessly so, for example, a file can be dragged from a Windows application straight into a Macintosh application.

Alongside this development, Intel, the manufacturer of 486 chips, have produced a new generation known as Pentium 586 chips. Like the PowerPC processors, the new Pentium chips will operate much faster than existing chips. Many new operating systems are in the pipeline, such as Windwos 95, replacing the cumbersome MS-DOS with much easier and faster systems of operation.

Practical advice on setting up a computer-based imaging system

Absolute minimum specification

A computer *capable* of 40 Mb of RAM and a hard disk of at least 750 Mb and a 24 bit colour display.

Hard drive storage

No hard disk is too large and the difference between 500 Mb and 1 Gb when purchasing a system can be as low as a hundred pounds. It therefore pays dividends to purchase the maximum size drive with the system. The only thing that can be guaranteed in computing is that in six months time a hard drive will be full.

The CD drive is an essential accessory for imaging. Besides being able to access PhotoCD, most software manufacturers offer the option of their programs on CD disk. These disks make it much easier to install the program and many use the extra space available on the disk to supply tutorials and sample images as well as demonstrations of other programs.

Expansion

Make sure that the computer is capable of expansion – imaging systems often require the addition of accelerator boards to speed up processing. Some PC systems require that SCSI cards are added before scanners and cameras can be connected. Some systems are primarily designed as home machines and offer very little opportunity for expansion. The minimum a system should offer is three expansion slots for cards to allow for improvement of the machine.

RAM

RAM memory or SIMMs are the most expensive element of the computing system. RAM is fitted inside the machine plugged into SIMM sockets on a memory board. The important thing to note is the maximum amount that can be fitted and this is limited by the number of SIMM slots on the machine. SIMMs or Memory chips come in different sizes normally 2, 4, 8, 16, 32 or 64 Mb modules.

On some older machines it is not possible to fit SIMM's except in groups of four.

For example with the Macintosh VX, 4 Mb of memory is an integral part of the computer circuit board. The VX has four SIMM slots and this offers the option of 8 Mb by adding a 1 Mb SIMM to each slot or 12 Mb by adding a 2 Mb to each slot. Note that if only 3 slots had SIMMs or if 2 x 1 Mb and

2 x 2 Mb were added the machine would not function. Later machines allow the option of mixing different sizes and not having to use groups of four SIMMs.

When buying a new system it makes sense to have larger size SIMM chips fitted. So for a configuration of 40 Mb on a system with 8 Mb on the circuit board and four slots rather than use all four slots on a 16 Mb + 8 Mb + 4 Mb + 4 Mb configuration a single 32 Mb will leave three slots free for further expansion. Also smaller SIMM chips tend to have little exchange value when expanding a system later. An example is that when the first systems were introduced 256 K modules were used these are now being recycled as cufflinks and badges.

Monitors and colour display cards

When purchasing a system remember that you may be spending a great deal of time looking at the screen so a good monitor is an investment. This is one area where the Macintosh system beats the PC system as many Macintosh computers are capable of displaying 24 bit colour straight out of the box. PC colour display cards can be very expensive if they are to give the same quality of colour on screen.

Graphics tablets

This is the only area in computers where the general consensus is that the smaller cheaper units seem to work better that the larger units. For general retouching the A4 or A5 size tablets offer more control than the A3. The exception is if the device is being used to trace a large image into the computer.

Software

All software piracy is theft and a crime. The FAST (Federation Against Software Theft) organization is dedicated to tracking down software copying and fining the perpetrator. Software can be an expensive investment and most software companies offer demonstration software with the save option disabled to enable a customer to test out software. These are normally distributed on 'try and buy' CD disks on which the full version of the package can be unlocked by payment to a phone number with a credit card.

Where to buy

Look for a reputable dealer who is local to your area. This may not appear to be the cheapest option in the short term but if you encounter any problems it will rapidly become an investment. Purchase from a dealer who offers the appropriate level of support to your needs. Some dealers may offer a more

expensive deal but this may include training for customers who are not conversant with computers. Clarify the service offered at the time of the initial quote and get it put in writing. This should include the terms of guarantee, the scope of service if included and the details of what will be supplied and installed.

In any system the whole is only as good as the weakest link. It therefore makes no sense to connect a £7000 scanner to an £800 computer and expect the results to be anything but poor. No photographer would use cheap lenses on their Hassleblad camera, and the same philosophy should apply to computing.

5 File size and storage

It will be apparent by now that digital images take up large amounts of storage space, and that one of the main problems of electronic imaging is that of storing and accessing the images.

Table 5.1 gives some examples of file sizes from different resolution scans of a range of print/transparency sizes. Scanner resolution is usually quoted in 'dots per inch' (dpi).

A simple formula can be used to calculate the approximate file size of an image:

no. of pixels horiz. x no. of pixels vert. = total no. of pixels
total no. of pixels x no. of bits/colour divided by 8 = total no. of bytes

for example an image has 1200 horizontal and 800 vertical pixels:

1200 x 800 pixels = 960 000 pixels
960 000 x (24 / 8) = 2 880 000 bytes (2.8 Mb)

The final file size will be determined by the format used to save it. As we have already seen, many file formats have compression routines built into them which will reduce the file size. Many national newspaper photographers now shoot exclusively on 35 mm colour negative film, which is then scanned using a 35 mm slide scanner, and downloaded into a portable computer when on location. Selected images can be captioned, compressed

Table 5.1 Scan size

	Resolution (dpi)	Colour	Monochrome
35 mm transparency	500	1.1 Mb	0.4 Mb
	1000	4.5 Mb	1.5 Mb
	2000	18 Mb	6 Mb
6 x 6 cm transparency	150	373 K	124 K
	300	1.46 Mb	497 K
	600	5.83 Mb	1.94 Mb
	1200	23.32 Mb	7.76 Mb
5″ x 4″ transparency	150	1.29 Mb	440 K
	300	5.16 Mb	1.72 Mb
	600	20.63 Mb	6.88 Mb
	1200	82.52 Mb	27.51 Mb
10″ x 8″ print	150	5.3 Mb	1.7 Mb
	300	21.3 Mb	7.03 Mb
	600	85.5 Mb	28.1 Mb

using JPEG or another compression program, and transmitted via modem back to the newspaper's head office for publication. After much experimentation they have found that scanning the negatives at 1000 dpi (giving a file size of 4.4 Mb) gives sufficiently good quality for reproduction on newsprint, at a file size small enough for rapid transmission when compressed.

Table 5.1 gives a clear indication that, before too long, the storage of digital images is going to lead to great problems. Several systems are available, and it is worth thinking very carefully about the system before investing.

Floppy disks

The 3.5″ disk is familiar to anyone using a computer for word processing and the like. Whilst the outer casing is rigid plastic, the magnetic disk inside is flexible, hence the term 'floppy'. A shutter opens when the disk is placed in the disk drive, to allow the reading and writing heads of the disk drive to access the disk. There are basically two types: double density and high density disks. The double density disk can store approximately 700 kilobytes of information, the high density approximately 1.4 megabytes. Before use, the disks must be 'formatted' (Apple refer to this as 'initializing') where the disk is divided into tracks and sectors by the disk drive. This enables it to receive the information to be stored on it. The disks can be locked, in much the same way as audio cassette tapes, preventing accidental addition or erasure of information stored on them.

Most electronic images will be too large to fit on to floppy disks unless they are compressed.

Hard disks

Most computers nowadays are fitted with an internal hard disk. Typical sizes are 40, 80, 230, 500 Mb and 1 gigabyte. Hard disks are used not only to store documents and images, but also the various programs used. For the storage of images, obviously the larger the better, and prospective purchasers would be well advised to get a 500 Mb or 1 Gb if possible. External versions are available, which connect to the computer, usually via a SCSI cable.

Like any type of disk, hard disks can become corrupted, or 'crash' causing the loss of some or all of the data on them. It is most important to keep a 'back-up' copy of that data on another disk.

Removable hard disks

Several companies, in particular Syquest™ and Bernoulli™ manufacture high capacity removable disks which can be used in a similar fashion to floppies. With the Syquest, a hard disk is enclosed in a 5¼″ casing, which is inserted

into a disk drive, usually attached externally to the computer via a SCSI cable. Syquest cartridges are available in three sizes, 44 Mb, 88 Mb and 105 Mb, and recently a new 3.5" version has become available.

The Bernoulli drive operates in an interesting fashion, making use of a concept in physics, the Bernoulli Principle, which is how an aerofoil gives an aeroplane lift. When the flexible recording medium spins at high speed, the air pressure created forces the medium to rise up towards the read/write head. There is no contact between the head and the disk, there being a gap of about 10 millionths of an inch between them. The system has the advantage that in the case of a power failure or knock, the disk loses some lift and falls away from the head, thus greatly reducing the risk of physical damage to the disk. Like the Syquest, the Bernoulli drive is available in a number of different capacities, including 90 Mb and 150 Mb.

Because the disks are removable, they are an ideal way of transferring large image files from one computer to another, perhaps to take an image to a bureau for output. The Syquest and Bernoulli cartridges are industry standards, and most bureau will have facilities for accessing the information on them.

Magneto-optical drives

This drive utilizes a laser beam, which is focused down on to a minute area of a disk composed of crystalline metal alloy just a few atoms thick. The laser beam heats the spot on the alloy past a critical temperature, at which the crystals within the alloy can be rearranged by a magnetic field. Read and write heads similar to conventional disk drives align the crystals according to the signal being sent. Two different sizes of disk are available, 5.25" and 3.5", in various capacities including, 128 Mb, 650 Mb, and 1 Gb, the commonest of which is the 128 Mb. These devices take about twice as long as conventional disk drives to record or read data, but the disks are relatively cheap.

DAT (digital audio tape) tape drives

These drives allow the storage of large amounts of information on small cheap tape cartridges. They work on a similar principle to video tape recorders. A recording drum with two heads spins at high speed. Tape is moved past the heads at a slight angle to them so that data is written to the tape as narrow diagonal tracks rather than a continuous track along the length of the tape. This increases the usable area of the tape allowing more information to be stored. Several sizes are available, such as a single 4 mm wide tape capable of holding 2 Gb of data. One problem with all tape systems is that if the information required is in the middle of the tape, the tape must be wound physically to that point. This makes them relatively slow for jumping backwards and forwards between files, but excellent when recording large

amounts of information in a sequential fashion. A special data format is used for storing information called DDS (Digital Data Storage) which not only indexes the information but also can search through the data very quickly. Whilst the tapes are very cheap, the drive units themselves are quite expensive.

CD-ROM and writable CD

The compact disk

The use of compact disk (CD) as a medium for delivering information is one of the fastest growth areas in the computing and publishing world.

Audio compact disks have been available for over ten years now, and vinyl records have become virtually extinct, with many new releases only being available on tape or CD. The major advantage to the photographic industry is that the compact disk format offers a method of storing, transporting and distributing the vast amounts of data needed to store photographic images at a low cost. The technology of storing digital information on compact disk has, within the last three years or so become available to photographers, librarians, educationalists and others involved in publishing. CD-ROMs are now available containing encyclopedias and dictionaries, multimedia presentations, and huge databases of library references and chemical and drug data. Many publishers are investing heavily in 'electronic publishing'. CD-ROMs can store up to 650 Mb of digital information on a single disk, but differ from other forms of storage in that the information is 'read only' (ROM stands for 'read only memory'), and cannot be altered. The disks have to be etched, or inscribed with a laser, meaning that producing disks is beyond the means of most photographers, although a new generation of disk recorders (CD-R) has become available within the last couple of years for about £4–5000 making it economical for small scale production of disks. Many companies offer a service of making disks from supplied information. Concern has been expressed in the media about the life expectancy of CDs. Estimates vary, but it is generally thought that undamaged disks can last for up to 100 years. (Syquest disks are guaranteed for five years, as are only many digital tape systems).

CD drive speeds

The introduction of the compact disk into the music world gave a cheap reliable method of storing 72 minutes of digital sound. The industry produced a drive that spun at a speed of around 200 rpm and would take 72 minutes to read a disk. The computer industry saw the disk as a good medium to distribute software, text and images. The drives used in the computer industry were modified music drives and therefore took 72

minutes to read a disk regardless of how fast the computer could process the information.

This speed has become the standard speed drive. Because computers can process information at much faster rates, faster drives are appearing on the market. The speeds of these drives are normally quoted in multiples of the 'standard drive speed'. There are now two times, three times, four times and six times drives. However the increase in speed of a times two drive will not translate into a two times increase in data transfer as other factors such as memory buffers, method of connection and even software slow the process.

The hardware

All CDs have several layers: a polycarbonate substrate which provides rigidity and keeps any scratches and blemishes on the surface out of the focal plane of the laser, a layer of metal acting as a reflective surface for the laser beam, and an acrylic layer on which the label is printed and which protects the metallic surface. Data is stored on the metallic layer as a pattern of reflective and non-reflective areas known as 'lands' and 'pits'. Lands are flat surface areas whilst the pits are minute bumps on the surface. These patterns are originally etched into the CD by means of a minutely small focused laser beam. When reading the disk the laser penetrates the polycarbonate layer and strikes the reflective metallic layer. Laser light striking a pit is scattered, whilst light striking a land is reflected directly back to a detector, from where it passes through a prism which directs the light to a light sensing diode. Each pulse of light striking the diode produces a small electrical voltage. These voltages are converted by a timing circuit to generate a stream of 0s and 1s, binary data which the computer can recognize.

The data is recorded along an extremely thin spiral track (approximately 1/100th the thickness of a human hair) which, if straightened, would be about 3 miles long. This track spirals from the centre of the disk outwards, and is divided into sectors, each of which is the same physical size. The motor which spins the disk employs a technique known as 'constant linear velocity', whereby the disk drive motor constantly varies the speed of spin so that as the detector moves towards the centre of the disk, the rate of spin slows down (Figure 5.1).

The mechanics

In order for a CD drive to function in conjunction with a computer three elements are required.

1. Hardware in the computer

The drive is a SCSI device and as such needs a SCSI card in the computer. Apple Macintosh computers have these as a standard fitting already installed

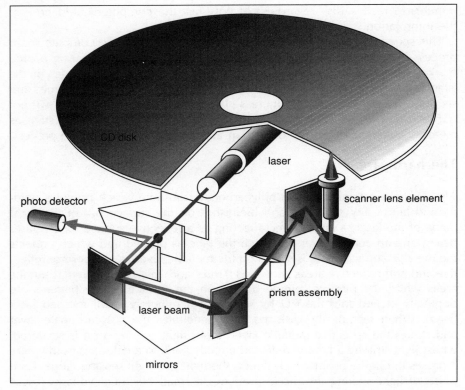

Figure 5.1 CD driver assembly.

as part of their system. PC type computers do not and have to have a printed circuit card physically placed inside the computer to allow the connection. Most PC cards combine the SCSI connection with a sound facility and are called 'sound cards'.

2. Driver software

This tells the computer what sort of drive is connected. The software should be supplied by the supplier of the drive. If problems arise when installing a CD drive on a PC system check that the correct software has been installed. The main problem is that in the case of ready made systems most suppliers only bother to install all the relevant software on the first machine, then make a copy and use this as a quick way of preparing subsequent machines. If the supplier changes the type of CD drive they use to multi session or a different model the drive will not read disks properly.

3. The drive

There are currently two types of drive available: multi session and single session. Both recordable and PhotoCD disks allow the user to add more data to an existing disk. In order to access the later data the drive needs to be multi session also known as XA compatible. A single session drive will only read the first recorded session of data.

Recorders (CD-R Compact Disk Recordable)

In addition to CD players, recorders are now available which allow the user to record their own data on to CD disks. A mass produced disk will still be stamped out in a press, but the writable format disk is constructed by a different method. The writable disk is a sandwich of a layer of gold foil with a layer of dye below it. The writing process uses a laser to write the information on the disk by heating a spot in the dye layer. This heat is transferred to the adjacent area of the substrate which is physically altered such that it disperses light. In areas left untouched by the laser, the substrate remains clear allowing the laser light reflected from the metallic layer through so that it can be read by the detector. The major advantages of the use of the CD disk are the size of the disk and the cost per unit. The CD writeable disk allows the storage of 650 MB of information at a cost of between £10 and £15 per disk. This cost works out at approximately 2p per megabyte – one of the cheapest forms of data storage available. The writable medium provides a cost effective method of distributing small numbers of disks. When producing larger numbers of disks economies of scale can be achieved by creating a master disk and pressing copies. The cost of mastering a disk is quite high but subsequent copies are much cheaper than their writable counterparts.

Formats

The operation of the writer allows the user to choose the format in which the data is stored. There are several different ways of arranging the data on the disk depending on the end use.

Digital audio

The establishment of a standard for recording music to CD disk was outlined in a book known as the CD-DA or Red Book. The data format divided the disk into a table of contents, the position and length of each track in terms of minutes and seconds. Care should be taken not to play other formats of disk in music players as this can damage the player.

CD-ROM

The first standard agreed for computer applications was the CD-ROM outlined in the Yellow Book. This type of disk was primarily designed as an advanced form of music storage with methods of checking the validity of the data with the added capacity of storing computer data. The format is not in current use for computer data.

High Sierra

This was the first true computer data format and the disk organization allowed the disk to be recognized by Apple Macintosh, PC and Unix machines. Again the format has been superseded by later methods.

ISO 9660

This is one of the currently supported formats by most authors of disks. The format will allow the data to be read by Macintosh, PC and Unix workstations. There are certain restrictions in writing ISO 9660 disks. The most relevant is that file names on the disk must be only seven letters long.

CD-ROM XA

This system is similar to ISO 9660 but allows the addition of data to an existing disk also known as multisession.

Other formats include CD-I, CD-R, CD-MO and CD-BRIDGE. These have been developed to support the home entertainment consoles for games and films and are not normally considered computer playable disks.

Native format

In this method the disk will make a copy of the hard disk in the computer. The drive will be fooled into thinking that another hard drive is connected to the computer. Everything will operate as with the normal hard drive with the exception that no information can be altered or written to the disk. This is an obvious method for protecting the information on the hard drive of the computer against loss or damage.

CD in action

The adoption of CD drives by computer users is increasing at a dramatic rate. Given the increase in potential users many companies are now distributing information by disk. This can represent substantial saving over distributing the same material as printed information. CDs are being used increasingly by

picture libraries to replace their printed catalogues. They can contain several thousand low resolution images together with a keyword search database for searching through the disk. Other companies are now marketing disks containing high resolution copyright free images which the client buys outright and uses in the same way as computer clip-art. These disks contain images of subjects such as cities of the world, backgrounds for presentations, historic cars, etc. Generally, CD-ROMs are available in either PC or Macintosh format, whilst Photo CDs are compatible with both platforms.

CD-ROM publishing

Many book publishers are investing heavily in CD-ROM publishing. Encyclopedias, dictionaries, bibles and other traditional 'books' are now available in CD format, often as multimedia versions. Every secondary and primary school in Britain has a CD-ROM drive offering publishers a huge market for educational material. The use of disks and the rights offered to the purchaser varies between publishers. Here are three different types of disks and their publisher's approach to usage.

1 Letraset phototone backgrounds (Plates 25 and 26)

This is a collection of over 500 images suitable for background material to illustrations and presentation. The CD comes with a database program on the disk to allow the user to browse through the images and create their own personal database on their computer. The collection includes such material as marble surfaces, wood bark, abstract images of nature and industrial products. The system adopted by Letraset is to supply the images in a quality suitable for display on a computer screen. Letraset grant the copyright use of the images in presentation packages at computer screen resolution, higher quality images can be ordered by phone and a '5 x 4' transparency will be dispatched by post.

2 Coral draw professional photos (Plates 27 and 28)

These are a series of disks covering a wide range of subjects. The disks are supplied with the images in PhotoCD format. The disk comes with a database program to allow the user to catalogue the images with their own descriptions and keywords. The disk also includes a screen saver program that displays images from the disk at random.

3 Creative interactive database

This is a portfolio of the work of photographers and illustrators created to provide designers commissioning work with examples of the character and

style of various photographers and illustrators. After finding a suitable photographer, the user is then given details of the address and a contact phone number to arrange further contact with the photographer. The images are designed only to display the photographers' work and no copyright granted to the disk user on the image displayed.

Marketing your own images

The simplest method of marketing images on CD is to contact one of the companies currently distributing photographic images on disk. These companies are orientated towards distributing collections of similar subjects. From the photographer's point of view a series of a minimum of a hundred photographs on a set theme would be the product such a company would be interested in. Subjects can range from British birds, steam trains, classic cars, etc. As with conventional picture libraries it is worth contacting the companies first and asking for a list of most wanted subjects prior to any submission.

A further development would be to create and market your own images. The cheapest solution would be to have PhotoCD disks created from a number of images and advertise these in the relevant press. A further step would be to purchase a CD writer and create your own disks, choosing the type of image file most suitable for your market.

CD writable also provides a relatively low cost method of supplying photographic work in digital format to the customer, especially as the ISO 9660 format will mean that any conflict between the computer platforms will be overcome.

A further development in the PhotoCD product is the implementation of Portfolio disk. This allows the user to create a presentation combining PhotoCD images, photographic images from other sources, graphic files and sound to produce a presentation program on their computer. This program can then be transferred on to a Portfolio disk. The major advantage of the system is its ability to play on any platform of computer to be used on a portable PhotoCD player with a domestic television without the need for a computer to be present at all. The system allows the creator to incorporate a level of interactivity with the program and create menu screens allowing the user to navigate their own path through the program.

The use of products such as Portfolio and PhotoCD provide a dynamic method of presenting a photographer's work to potential clients. The relatively low cost of duplicating disks compared with duplicating film originals means that a larger market can be targeted. In addition the fact that the disk is only a copy of the original films means that the potential loss of a disk is less damaging from the photographer's point of view.

6 Image processing

In order for the computer to enhance, manipulate or analyse images, it must contain image processing programs (software). There are very many different programs available, varying both in their capabilities and price. Many of the less expensive programs will still carry out a wide range of image enhancement and retouching procedures, and it is worth examining these carefully to see if they are adequate for the purpose required.

These imaging programs are known as 'paint' programs, and in them each image is composed of a rectangular grid of pixels known as a 'bitmap'. Each pixel is assigned a value, from one bit (black or white) to 24 bits per pixel for full colour images. Because bitmapped images contain a fixed number of pixels, the resolution (pixels per inch) is dependent upon the size at which the image is printed. Other programs, used primarily for drawing and graphical illustration are known as 'object-oriented' programs, and include Adobe Illustrator™ and Aldus Freehand™. These use mathematical formulae to define lines and shapes (for example, a circle can be described by the formula $x^2 + y^2 = z^2$). The artwork is built up from a series of separate components, each of which is independently editable. Because an image composed with an object-oriented program is made up of mathematical data, the resolution is dependent upon the output device, be it a laser printer or high resolution imagesetter.

The photographic imaging programs can be broadly divided into those for image retouching and manipulation, those for scientific image analysis, and those designed for enhancing images before outputting to print and other media. There is considerable overlap between them, and increasingly powerful programs are constantly coming on to the market.

Image retouching and manipulation programs

There are many examples of this type of software, including Adobe Photoshop™, Letraset Colour Studio™, Apple's PhotoFlash™, Picture Publisher™ from Micrografx and Aldus Photostyler™. When desktop computers suitable for imaging first became available, most of the programs were written for the Apple Macintosh computer, but now many programs are available for PCs as well. Images can be easily transferred between the two platforms using file conversion programs such as PC Exchange. Programs are updated at regular intervals by the authors, and it is very important to register your software immediately with the manufacturer to ensure that you receive the latest versions and upgrades. The potential of the programs is

huge, and here we can only look briefly at the operations possible. It is essential to spend time reading the manual supplied with the software, and carry out the suggested tutorial exercises. It will take a long time to become proficient with all areas of the program, but the basic operations will become familiar relatively quickly.

Most of these programs will perform all of the familiar operations of image adjustment which photographers now carry out in the darkroom such as altering the brightness, contrast and colour of images, dodging and shading, sepia toning, posterization and solarization, and even conversion from negative to positive and vice versa. But on top of this, the computer is capable of performing many operations not possible with conventional photography. Some, like PhotoFusion™, use technology from the film and video industry to help combine foreground and background elements.

To describe the potential of the software available, we shall use the example of Adobe Photoshop™, probably the best known of the packages currently available. It has become an industry standard, certainly in the UK, and many add-ons (or 'plug-ins') are available, such as extra filters, texture generators and specialist accelerator cards. It also serves as the host software for the software plug-ins supplied with many scanners, digital cameras and printers to control them. The current version of this program (2.5.1) is available for the Macintosh, PC and Unix platforms, and its basic operations are very similar on all of these systems. As a general rule, the computer should be equipped with three times as much RAM as the largest image size which you intend to manipulate. Thus, with an 18 Mb PhotoCD image for example, 45 to 50 Mb RAM is desirable. This means that most of the image processing is done with the RAM, rather than the much slower virtual memory system using the hard disc.

Adobe Photoshop

Upon opening the program, the screen will be seen to display a menu bar at the top, and a toolbox running vertically down the left hand side (Figure 6.1).

Images stored in a large range of file formats can be opened. The software also has various 'acquire modules' often supplied with scanners and digital cameras, and PhotoCD, so that the device is actually accessed through Photoshop.

The 'toolbox' contains familiar items such as pencils, paintbrushes and buckets, rubbers, dodging sticks, together with others for selecting areas of the image, creating text, cropping images and filling selected backgrounds with a gradient (Figure 6.2).

Tools are selected from the toolbox by clicking the cursor on the required one, then taking it into the image area. The arrow cursor then changes to the shape of the tool in use. There are a total of 40 different cursors within

Figure 6.1 *Screen view of Adobe Photoshop showing toolbox and menu bar, open image, brushes palette and 'info' window. This shows X, Y co-ordinates and 'K' (black) density of pixel under cursor. Note image size at bottom left of image (1.49 Mb), also items on desktop: two hard disk icons, network control software (Timbuktu), Syquest disk icon (Adrian Davies 3) and PhotoCD icon.*

Figure 6.2 *Adobe Photoshop 2.5 'toolbox' containing a range of selection, cropping, drawing, painting and enhancement tools.*

Photoshop. With most of the tools, double-clicking with the mouse brings up a range of further options which may be selected. For example, double clicking on the *lasso* tool allows you to 'feather' a selection, giving it a soft rather than a hard edge, and double clicking on the *gradient* tool allows you to select different types of gradation such as linear or radial. Some of the cursors, such as the rubber stamp and the paintbrush, are quite large, and may obscure parts of the image if highly precise work is required. By depressing the 'caps lock' key, the cursor changes to a crosshair, which doesn't interfere with the image being viewed.

Selection tools

These tools enable you to select parts of an image for modification or adjustment. The *rectangular* and *elliptical marquee* tools enable selections of these shapes, whilst the *lasso* tool is used to make freehand selections. The '*magic wand*' is used to automatically select parts of the image based upon the colour similarities of adjacent pixels. It can be used to select part of an image such as an even toned background. The tolerance of the wand can be set so that it looks for a very precise group of pixels, or those that are similar to the point on which it was placed.

Once selected, the required area is outlined by 'marching ants', an animated dotted line. When applying modifications to the image, only the area selected is affected. The most precise way of selecting a part of an image is the *pen* tool, found in the 'show paths' from the window menu. The required area is selected by making various points around the item. The selected area can be saved as a *path* which can be edited very precisely. Selections can be 'feathered' – their edges can be softened by varying amounts to make it easier when merging them with other images for example.

Cropping tool

This tool is used to select a part of an image and discard the remainder, in much the same way as trimming a photographic print. Always crop an image removing any redundant or unwanted information to obtain the smallest possible size and save on memory. The cropping tool can be set to give a pre-determined size, useful for cropping images to fit precise spaces in page layouts.

Text tool

Text can be entered on to an image, in a range of sizes, font styles (those installed on the computer) and colour. Images can be labelled or captioned. The colour of the text is that of the foreground colour palette, so ensure that this is set before adding the text to an image. Text can be moved around on an image until it is in the required place, when clicking outside it will 'lock'

the text on to the image. Being a 'bitmap' type of program, Photoshop is not an ideal program for the generation of text – the resolution of the type is dependent upon the resolution of the image. If very precise textual labelling is required, it may be better to import the image into a vector based program which has better text capabilities.

The style of the text can be selected, and it can be filled with a gradient colour for example, or made translucent, and a photographic image made to fill the text.

Hand tool

Where an image is larger than the displayed window, the hand can be used to drag the image within the frame.

Zoom tool

This tool allows you to zoom in on an image or zoom out. When first selected, the magnifying glass will display a plus sign, and will enlarge the image when clicked, to a limit of 1600%. If the option key is held down a minus sign appears, and the tool will now zoom out, or reduce the magnification, to a limit of 6%. Placing the tool on a particular part of the image will enlarge that part.

Painting and drawing tools

The next eight tools in the Photoshop toolbox are concerned with painting and drawing. The *pencil, paintbrush* and *airbrush* are all self-explanatory. Their size and characteristics can be altered in the 'show brushes' window. The colour applied will be the colour displayed in the foreground colour box at the bottom of the toolbox. The *pencil* is used to paint hard edged lines or dots, the paintbrush soft edged strokes, whilst the airbrush lays down a diffused spray of colour. The way in which the colour is applied can be altered in the show brushes window as can the shape and size of the brush. Adjustments can be made to the opacity, saturation and many other modes of application. For example, applying colour in 'normal' mode lays it down as a solid colour, whilst applying it in 'color' mode will lay down colour without altering the lightness and darkness of individual pixels. This mode is particularly useful for changing the colour of areas of an image, or colouring monochrome images. To do this, convert the greyscale image into RGB (the file size will increase by a factor of three), then apply the appropriate colour.

The *eraser* is used to erase parts of an image. The eraser will remove the image down to the background colour displayed at the bottom of the toolbox. The eraser can be converted into the 'magic eraser' which will remove any modifications made, and restores parts of an image to the previously saved version.

The *line* tool is used for laying down straight lines, at any angle or length. It has the option to have arrowheads at the start or end, and be drawn in a variety of thicknesses. It is useful for producing annotated photographs.

The foreground colour in the toolbox can be selected by clicking the *eyedropper* tool in any part of the image. This colour will now be used by the other drawing tools until another is selected.

The *cloning* (or *rubber stamp*) tool is potentially one of the most useful in the toolbox. It allows you to sample a part of an image and place an exact copy (clone) of it elsewhere in the image, or in another image. Extensive options allow the cloning of patterns, or an 'impressionist' style. In the example, areas of sea were cloned over the seagull to erase the areas no longer required.

The *dodging* and *burning* tools operate in much the same way as dodging and burning-in in the darkroom, making areas of an image lighter or darker. The size of the tools can be adjusted in the 'show brushes' window, as can the degree of dodging and burning.

The *smudge* tool smears colour in an image, in much the same way as dragging a finger through wet paint.

The *blur/sharpen* tool will blur or sharpen small areas of an image, without resorting to the blur/sharpen filters from the filter menu. There is not so much control over the process as with the proper filters.

The menus

The menu bar at the top of the screen contains sub-menus for such operations as changing the mode of display of the image, adjusting brightness, contrast and colour balance, applying electronic filters and controls for copying and pasting parts of images together.

When working with large images, particularly on relatively slow computers, it is good practice to select a small part of the image, make adjustments to that area, and then apply the settings to the whole image when the desired result has been achieved.

Mode

This menu allows you to convert an image displayed in one mode to another. For example, a greyscale image can be converted to a RGB display. Although it will not look any different, it now allows the addition of all of the colours within the paint palette – like hand colouring a monochrome print. One consequence of this conversion is that the file size will increase by a factor of three.

Another conversion for greyscale images is to produce duotones, tritones or quadtones, whereby the image is printed with two, three or four inks. In duotoning, for example, an image can be displayed using black and one other colour, perhaps an orange. This will result in a sepia toned image. The

colours chosen relate to the Pantone series of printing inks. The inks can be assigned to certain areas of the image, such that the darkest values will print as one colour, the lightest perhaps as another colour.

RGB images can be converted to CMYK, enabling photographers to produce the four colour separations required for four colour litho printing.

Adjustment of brightness and contrast

This is one of the commonest operations required. The brightness and contrast of both monochrome and colour images can be adjusted to great degrees by a number of different methods. The most straightforward is to use simple slider controls on the screen to increase or decrease the overall brightness or contrast. A better, more specific method is to use the 'levels' control, which allows fine adjustment of shadow, midtone or highlight areas by modifying the 'histogram' of the displayed image. This is a graphical representation of the image showing the numbers of pixels with a certain colour value or density. The width of the histogram represents the possible brightness values. The vertical heights represent the number of pixels in the image having that density value. Using the levels control, you can remove densities from shadow or highlight areas of the image, and adjust overall brightness. Another method of adjustment is to alter the shape of the 'curve' of the image. Like the characteristic curve of a photographic emulsion, the curve for the 'gamma' of the image relates the original brightness values of the pixels along the x axis, to the new brightness values or output levels on the y axis (Figure 6.3). Changes to the contrast and brightness of images can be made in very similar ways to modifications by development in film processing.

Adjustment of colour

The colour balance of an image can be adjusted in a number of ways. Sliders enable the addition or subtraction of a colour, or the hue and saturation of colours. These alterations can be made to the whole image, or to shadows, midtone and highlights independently. In photography, faulty processing of colour film can lead to the problem of 'crossed curves', where the shadows have a certain cast, and the highlights a cast of the complementary colour. This is extremely difficult to correct using traditional photographic techniques. Using the curves control in Photoshop, such problems can now be corrected almost entirely, and very easily. A leading natural history photographer recently returned from a trip to photograph mountain gorillas in Rwanda. Several rolls of his transparency film were inadvertently processed as negative. This too was corrected almost entirely using the 'curves' and 'levels' controls. Old transparencies often have a colour cast, usually magenta or blue, when one of the layers fades more quickly than the others. These too can have the colour and contrast enhanced, perhaps to make them commercially usable again.

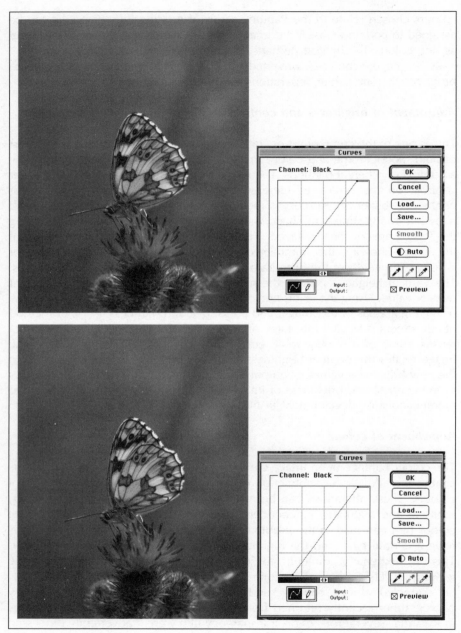

Figure 6.3 Top: Image of Marbled White Butterfly taken directly into Adobe Photoshop from PhotoCD, together with 'curve' of image. Image shows lack of contrast. Bottom: Image enhanced using 'curves' control. This complex control acts in a similar way to the characteristic curve of a photographic emulsion. In this case, increasing the angle of the curve leads to an increase in image contrast. Particular points in an image can be 'mapped' to particular points on the curve.

Plate 1 Photograph of the imaging CCD element used in the Kodak DCS200 digital camera.

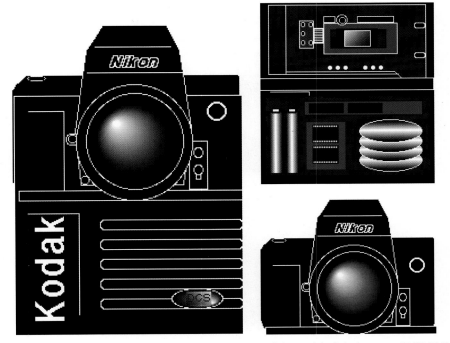

Plate 2 Schematic diagram of the internal structure of the Kodak digital camera (DCS 200).

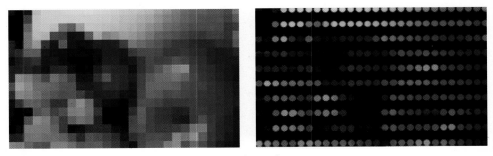

Plates 3–4 Two types of CCD pixels: square and round.

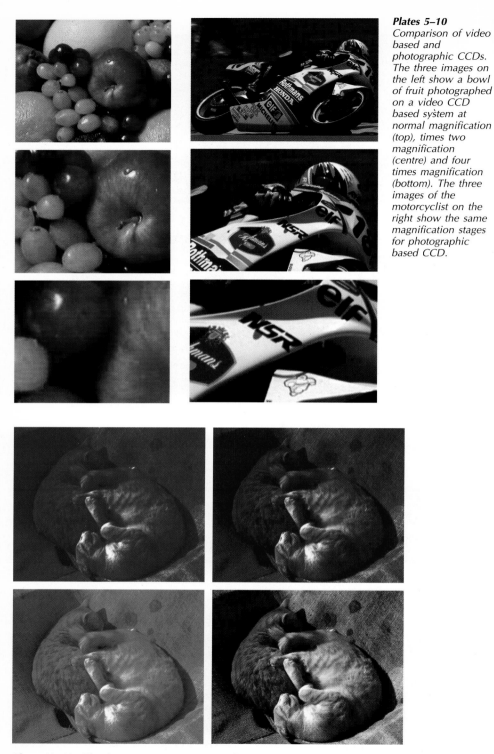

Plates 5–10
Comparison of video based and photographic CCDs. The three images on the left show a bowl of fruit photographed on a video CCD based system at normal magnification (top), times two magnification (centre) and four times magnification (bottom). The three images of the motorcyclist on the right show the same magnification stages for photographic based CCD.

Plates 11–14 The three pass capture system. The camera captures the image as three black and white pictures each through a different filter. These three images of the red, green and blue content of the image are then recombined in the computer.

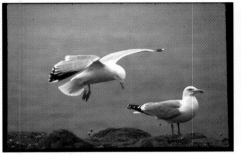

Plates 15–16 Left: Original image of gulls from PhotoCD. Note slide border and dust specks over image. Right: Right hand gull turned, as described in text. Dust particles retouched. Contrast and brightness enhanced.

Plates 17–18 Example of retouching by John Henshall. A glass plate in the Royal Photographic Society collection was badly damage and successfully retouched using Adobe Photoshop (Courtesy of RPS).

Plate 19 Copyright images: low resolution copy.

Plate 20 'Watermarked' image.

Plate 21 With added logo.

Copyright Phil Fennessy

Plate 22 With your details added.

Plate 23 *Increased size of 'canvas'.*

Plate 24 *Added copyright details.*

Plates 25–26 *Photone disk published by Letraset showing the range of textures and backgrounds for presentations and publishing.*

Plates 27–28 *CorelDraw disk showing the built-in database manager system.*

Several of the programs available, such as Photoshop and EFIColor Cachet™, are capable of displaying the equivalent of a colour ring-a-round, making the judgement of a colour cast a relatively easy matter.

One of the most important features of many image processing programs, and some desktop publishing programs such as QuarkXpress™ and Pagemaker™, is their ability to separate the image into 4 colours, cyan, magenta, yellow and black (CMYK), suitable for a printer to make printing plates of each of the colours for reproduction. The process is rather complicated with many variables and is beyond the scope of this book. It requires calibration of monitors, printers and inks, and photographers regularly requiring this facility are advised to look at other programs such as EFI Cachet™, which is designed primarily for producing colour consistency across a wide range of output devices, and to liaise closely with their printer. Many printers and bureaus recommend that photographers supply their digital images as RGB files, and have the separations made by the bureau.

Image

In this part of the menu, images can be rotated, their shape distorted and even the perspective corrected. Images of buildings displaying 'converging verticals' when photographed on small or medium format cameras can be corrected here. Images can be re-sized, and the resolution changed. Re-sizing can be carried out by percentage, or specific measurements. If the image size is to be increased, then it may be necessary to increase the resolution. This, however, does not necessarily produce a higher quality image, as in order to increase resolution, the software has to create new pixels through a process called *interpolation*. This process is also used by the software when images are rotated by anything other than 90° increments or distorted. Three methods are available within the software for creating the new pixels, and are to be found in the general preferences menu. The options are: bicubic, nearest neighbour, and bilinear, and refer to the mathematical algorithm used in the process. The method giving the best quality result is the bicubic option, though it is significantly slower than the other two. The nearest neighbour option gives the poorest quality.

Filters

A large range of electronic filters is present with the software, and many more can be bought from third party suppliers for a range of applications, in the same way that photographers can buy a large range of optical effects filters for lenses. These electronic filters include a number of options for enhancing images, such as a range of sharpening filters. Others reduce 'noise', blur or diffuse images. A wide range of effects filters is available to distort images, add the effect of paint or grain and a multitude of other effects including one for adding the effect of lens flare to images! A brief

discussion of the mathematical operation of filters is given in the image analysis section later in this chapter, and some examples are shown. It is also possible to customize the filters for your own specific operations.

Other features

Photoshop has a large range of other facilities, too great to detail here. A short list is given below of some of the more useful.

1 A built-in densitometer. In the windows part of the menu is an option 'show info'. Here, one can get information regarding the density, or colour composition of any pixel on the screen, and its position within the bitmap.
2 'Show channels'. This command allows you to view each component channel of the image separately. An RGB image can be split into its three components. One of these, the green channel for example, can be lightened or darkened, and the image reconstituted. This is useful if the image shows the effect of 'crossed curves' with shadows of one colour, and highlights of its complementary colour.
3 Selected parts of an image can be copied, and 'pasted' into other images, or back into the same image. The pasted image can be rotated or flipped, altered in terms of its transparency, and have its edges softened by feathering.

To illustrate some of the manipulation features of Photoshop, two examples are shown on Plates 15–18. The procedures for the manipulations shown are as follows:

Image no. 1: (Plates 15 and 16) In this image, the seagull on the right of the picture is looking the 'wrong' way. The bird was selected using the pen tool, creating a 'path'. The path was converted to a selection, which was copied and pasted. The pasted image was 'flipped' horizontally, from the image menu. Whilst it is selected the pasted image can be moved into the best position. Care was taken to line up the rock on which it was standing, for example. The image of the original bird now need to be removed. This was achieved using the cloning (rubber stamp) tool, selecting various parts of the sea and overlaying them over the bird. Care was necessary when working close to the 'new' bird. The image was magnified using the magnifying glass tool making it easier to retouch. Finally, the image generally was 'cleaned' removing dust spots from areas of sea, again with the cloning tool. A couple of the purple flowers were cloned to add some more to the clifftop. The original Kodachrome transparency was scanned and transferred on to PhotoCD, from where it was imported into the computer. The file size was 4.4 Mb.

Image no. 2: (Plates 17 and 18) The second example shows how British electronic imaging expert John Henshall reconstructed a broken Autochrome

plate from 1908 using Adobe Photoshop. The plate, broken into many pieces shows a self portrait of the British photographer Alvin Langdon Coburn, and is in the collection of the Royal Photographic Society. The glass fragments were first laid out on a light box and photographed on to 35 mm colour negative film, which was scanned at 2000 dots per inch, using a Kodak Rapid Film Scanner, giving an 18 Mb file. Alterations to the colour balance to counteract the fading of the original were carried out at this stage. Extensive use was made of the cloning (rubber stamp) tool, to fill in gaps. No 'drawing' was carried out – every part of the restored image was present somewhere in the original.

This use of digital image processing will become a valuable tool to archivists enabling retouching much more quickly and cheaply than before.

Image analysis programs

Much of the research which has brought us inexpensive desktop computers and imaging programs came from the space programme, where images were sent back from space and enhanced by computer back on earth. Today, scientists at NASA and other remote sensing institutions routinely apply image processing techniques to the images transmitted from satellites, to improve their quality by removing transmission noise, as well as gathering data from them. Before it was repaired, images from the faulty Hubble Space Telescope were enhanced and filtered by computers at NASA. Scientific image analysis programs have been available for PCs for a few years now, and several are available for the Macintosh platform as well. Like the retouching and manipulation programs, there is a wide variety available, used by biomedical photographers for example, for analysing microscope images, and forensic units of police forces for taking measurements from scene of crime pictures. For the PC, good examples are PC Image and Global Lab, whilst for the Macintosh, Optilab™ and Image 1.52 are excellent programs. This latter program is remarkable in that it is within the Public Domain, i.e. it is free, and available from Public Domain software suppliers (addresses can be found in the back of computer magazines). It is capable of many of the functions of other programs, and is highly recommended. It is included on the enclosed CD.

In many respects, at first sight the image analysis package is similar to a paint program like Photoshop, with a toolbox containing selection tools, pencils and brushes, and a menu bar with menus for adjusting modes of display. Also like Photoshop, various filters are available for increasing sharpness and reducing noise. Most have the facility for writing one's own filters for specific uses. Figures 6.4 to 6.9 show a variety of processes and applications.

Figure 6.4 Screenview of 'Image 1.52', a Public Domain image processing program for the Macintosh, showing Look Up Table (LUT), toolbox, open image of blood cells, 'Map' window for adjustment of brightness and contrast, 'Values' box showing X, Y co-ordinates and some of the possible measurement options.

Figure 6.5 Greyscale image of blood cells with associated 'histogram'. This is a graphical representation showing, for each of the 256 possible grey values, the number of pixels within the selection having that grey value.

Figure 6.6 Greyscale image of blood cells, with pixel density profile plot along the selected line.

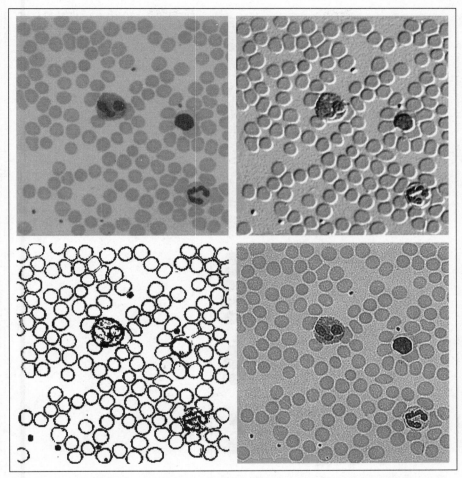

Figure 6.7 *Top left: Photomicrograph of blood cells as a 'greyscale image'. Top right: 'Shadow' effect applied to give depth effect. Bottom left: 'Trace edges' filter applied. Bottom right: 'Sharpen' filter applied.*

The main purpose of the package however is to analyse images, and gather data from them. The packages can count particles, measure areas, lengths or perimeters, measure densities and produce density plots from a line drawn across an image. This is commonly used, for example, in the analysis of electrophoresis gels in biology laboratories (a scanner can, in effect, be converted into a densitometer for various photographic purposes). Density slices can be made from an image, highlighting all parts of an image having equal density. A group of images, perhaps the same subject taken over a period of time, can be laid on top of each other, and 'animated' so that differences between them can be shown.

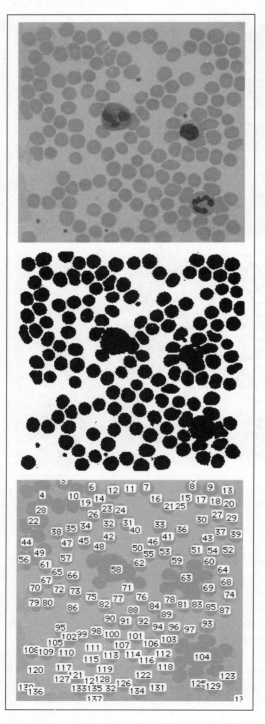

Figure 6.8 *Image 1.52 used to count blood cells. Top: Original greyscale. Centre: Image 'thresholded'. Bottom: Cells labelled using 'analyse particles' command.*

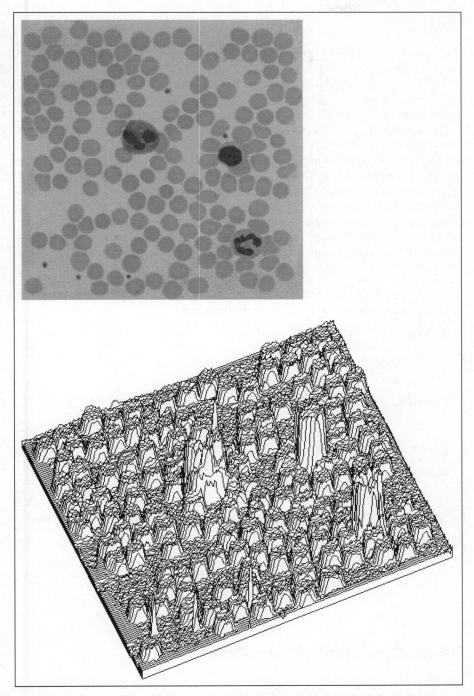

Figure 6.9 Top: Greyscale image of blood cells. Bottom: 'Surface plot' of above image.

Filters

Image analysis programs have a similar range of filters to Photoshop, such as the sharpening filter, but also include many others to enable photographers and scientists to extract information from images. Filters with names like Laplacian, Sobel and 'mexican hat' can, for example, isolate vertical or horizontal lines, sharpen or reduce 'noise' in images.

The operation of filters is complex, but basically a mathematical process is applied to a group or matrix of pixels within the original image. This might be 3 x 3, 5 x 5 or anything up to 63 x 63 in area. Values are written within the matrix, which are applied to the pixels of the original image. The filter scans across the image, starting in the top left-hand corner. The filter, and the section of the image which it overlays are multiplied together. The result of the calculation replaces the central pixel. For a 3 x 3 'smoothing' filter, the average of the 9 pixels is substituted for the original value. The filter is shifted to the right by one pixel and the process repeated until the entire image has been filtered.

Examples of filters using a 3 x 3 group of pixels:

Sharpen: –1 –1 –1
 –1 9 –1
 –1 –1 –1

This is just one of many types of sharpening filter.

Smoothing: 1 1 1
 1 4 1
 1 1 1

This filter blurs (softens) an image, and can also reduce 'noise'.

Shadow: –2 –1 0
 –1 1 1
 0 1 2

This produces a shadow effect with the light appearing to come from lower right.

Trace Edges: 1 1 1 –1 0 1
 0 0 0 –1 0 1
 –1 –1 –1 –1 0 1
 traces horizontal edges traces vertical edges

Future developments in software

Developments in hardware and software are happening very rapidly, and it is likely that new processors will become available enabling greater speed

with existing programs. New programs written specifically to make use of PowerPC or Pentium chips will be able to perform complex imaging procedures much more quickly than at present, and to much larger images. The addition of post processing techniques to manipulation software will radically speed up their operation. One example of this approach is a new software package called Live Picture™ . Announced initially in August 1993, this package is capable of manipulating very large image files (up to 300 Mb) in almost real time on Macintosh Quadra computers with a minimum of 32 Mb RAM. It does this by generating a new file format called IVUE from an original TIFF image. This new file consists of the original image, together with a sequence of reduced resolution views. This image data is organized in such a way that a new screen display can be constructed very rapidly. The original file is left untouched, whilst modifications and enhancements are only made to the screen images. These changes are stored, as layers, as mathematical data (much quicker than bitmaps). A complex painting sequence for example will only be stored as the data describing the whole modification. This means that the program offers resolution independence – the image is not composed of pixels. When the work is finished, the final image is 'built' using a post-processing stage, when all the layers are brought together as a resulting TIFF file. At present, this may take in the region of 12 minutes for a 26 Mb file giving an A4 size image at 300 dpi.

A similar approach has been taken by another piece of software Collage™ by Specular International. This operates in conjunction with Adobe Photoshop, making screen resolution 'proxies' of high resolution images which can be manipulated in real-time. Once all the manipulation has been carried out, the program goes back to the original high resolution version and applies all of the effects required.

File formats

When images are captured electronically, either by electronic cameras, or by scanning conventional silver based photographs, they must be stored as a particular type of file, known as the *file format*. Many different image file formats exist, and it is essential to have at least a working knowledge of the main ones to ensure that a particular image can be transferred to another program, such as a desktop publishing package, or sent in the correct form to a printer or other form of output medium. Some programs will only open specific file formats, whereas others, such as Photoshop will open a wide range. Some programs (for example, DeBabelizer™) are available whose primary function is to convert files from one format to another. Examples of file format used for both Macintosh and PC type computers include TIFF, PICT, EPS and Photoshop.

TIFF (Tag Image Format File)

This file format was developed in 1986 by Aldus and Microsoft to try and standardize the growing number of images being produced by scanners and other digital devices, and needing to be imported into desktop publishing programs. Blocks of data within the file are interpreted by the use of tags which identify them. Even so, there are several versions of TIFF currently available, though these generally pose few problems. It is a very widely used file format for bitmapped images for both the Apple and PC platforms, and is the best format to use for transferring images from one system to another or supplying images to a bureau. It is used extensively when making colour separations. Within TIFF a compression routine known as LZW is available (see image compression). Adobe Photoshop is able to read and save captions in TIFF files, particularly useful when used with the Associated Press Picture Desk, which uses the same caption fields.

PICT

This is the native graphics format for the Macintosh computer, and works equally well with both bit-mapped and object-oriented artwork. The current version is PICT 2, which supports images in any bit depth size or resolution. It is particularly effective at compressing images containing large flat areas of colour. If you have Quicktime installed on the Macintosh, then PICT images can be JPEG compressed. Such files can be opened up into word processor packages such as Microsoft Word™, and Apples' own TeachText. It should not be used for desktop publishing applications.

EPS (Encapsulated PostScript)

EPS uses the PostScript page description language to describe images and is used to export files (particularly those in colour) to page layout programs. It can be used for storing object-oriented graphics, as well as bitmapped images, though these may give very large file sizes. The way in which images are described by the PostScript language, using vectors, means that the resolution of the image is dependent on the resolution of the output device.

A variation of EPS, developed by Quark for its QuarkXpress desktop publishing program is called DCS (Desktop Colour Separation). This format enables users of QuarkXpress to print colour separations of imported artwork and photographic images. When saved in DCS format, five files are created: yellow, magenta, cyan and black, and a master document which is a PICT preview of the image which can be viewed and positioned within page layouts.

PhotoCD

The PhotoCD format uses the YCC colour model (a variant of the CIE colour space), giving a very broad range of colour. By opening PhotoCD images directly, the YCC images can be converted into Photoshop's Lab colour mode, ensuring no colour loss.

Photoshop

This is the native file format within Adobe Photoshop, and has the capability of retaining information relating to masking channels, etc. which may be lost when saving in another file format. Photoshop 2.5 has a lossless compression routine built into it. The format is recognized by many other programs which can open images stored as Photoshop format directly.

Whilst the above are perhaps the commonest and most familiar formats, a wide range of others are available, a selection of which are given in the following sections.

Amiga IFF (Interchange File Format)

This is Amiga's all purpose graphics file format, similar to PICT on a Macintosh.

Window's Paint BMP

This format is native to Windows and can be used to save monochrome and colour images up to 24 bit.

PCX

This is the file format used with one of the oldest paint programs for DOS, PC Paintbrush. A number of versions are available.

CompuServe GIF (Graphic Interchange Format)

CompuServe is a commercial on-line bulletin board using its own format for sending compressed 8 bit images by telephone lines. The compression used is similar to the TIFF LZW.

RIFF (Raster Image File Format)

Letraset's proprietary alternative to TIFF. Stores up to 32 bit information, but is only used with Letraset programs such as Colour Studio.

TARGA (TGA)

This is a bitmap graphics file format, used to store images up to 32 bit in RGB mode, used particularly for overlaying graphics and video.

JPEG

This is a lossy compression routine, capable of compressing images to a ratio of 20:1. It has rapidly become an industry standard. Users can set their own quality settings on a sliding scale within the software.

FIF (Fractal Image Format)

An uncommon format as yet, but one which may become increasingly important for storing large single images, or for video sequences. Compression ratios up to 600:1 are possible, without noticeable loss of quality.

Image compression

Images generally take up a large amount of computer memory. A 35 mm transparency, scanned at 1000 dots per inch will require over 4 Mb of storage space, as will the image from a colour DCS 200 camera. Photographers wanting to transmit images via modem and telephone line compress them first to save time on the transmission of the data. Compressed files must be decompressed before they can be manipulated or printed.

Digitally stored images may contain a large amount of redundant information which can be identified by the computer and removed for storage purposes. It may then be replaced when the image is required again. Image compression programs are now available which can compress images by varying amounts, and then re-compress them. Some will do this without any loss of image information – these are referred to as *lossless* programs, or algorithms, and will give a reconstructed image identical to that of the original. Lossless routines can compress to a ratio of 5:1. Other programs will lose varying amounts of information when the image is reconstructed, and are known as *lossy* routines.

An international standard for image compression has been developed by the Joint Photographic Experts Group (JPEG) and is included within such imaging programs as Photoshop, Photostyler and Picture Publisher. It is based on a complex mathematical procedure called DCT (Discrete Cosine Transformation) which examines blocks of pixels (perhaps 8 x 8, or 16 x 16) and performs an averaging operation of the colours. Larger pixels are created each of which is assigned a colour according to the analysis. The compression ratio can be selected within the program. In Adobe Photoshop a range of nine settings from fair to excellent quality is available. JPEG is a lossy

system, meaning that whatever setting is used, data are discarded, but if any setting from the fourth increment upwards is used when compressing, the loss will be minimal, probably unnoticeable. JPEG can be used for all continuous tone greyscale, RGB and CMYK photographic images. If you wish to compress line drawings and other high contrast images, a better scheme is the LZW compression routine found under the TIFF file format window. It can compress to a ratio of 1:10. This is a lossless compression routine which works by detecting strings of pixel patterns compared against reference tables. When compressing images, to maintain optimum quality it is best to carry out all manipulations and enhancements before compressing the image.

A new form of lossy compression is being developed for both still images, and digital video, which uses *fractal* mathematics. Fractals are the often incredibly beautiful shapes generated from mathematical equations. The process is still in its infancy, but already compression ratios of 600:1 have been achieved without noticeable loss of quality, compared with JPEG's 25:1. The process is much slower than JPEG. It is hoped eventually to be able, using fractal compression techniques, to fit full length feature films on to a single CD. The process is very mathematical and often requires special hardware.

Other software for electronic imaging

Image data bases

One major sector of the photographic industry eager to utilize the technologies of electronic imaging are picture libraries and archives. Some libraries are looking to the technology to store digital copies of their images, whilst others are looking to replace their printed catalogues with CDs, which can also contain keyword search databases. Obviously, for a library consisting of perhaps several million images, huge databases are required. However, for the individual photographer with perhaps several thousand images, smaller programs are available which are none the less very powerful in their search and retrieval capabilities. Two examples are Kodak Shoebox™ and Aldus Fetch™. Photographs can be given a number of keywords to describe them, which can be compiled into a database. The user can sort through images of different file types using low resolution thumbnails on the screen and keyword search databases. Most of the programs available can handle many thousands of images – for example, Aldus Fetch can handle up to 32 000 images. Several image processing programs, such as Micrografx Picture Publisher™ have basic image cataloguing capabilities within them.

Optical Character Recognition (OCR) for scanners

Whilst not strictly an imaging program, many photographers will find this software very useful. Pages of text, either typed or printed can be scanned

on a desktop scanner, and the text read and converted into a format readable and editable by a word processing package. Most of the software available nowadays, for example Omnipage™, is very good and will recognize pages of typed and dot matrix printed text as well as good quality laser printing. It works best with plain typefaces such as Times or Helvetica, in sizes from 9 to 12 pt. It is not so efficient with type that is too large, or printed on poor paper where the ink has spread.

Desktop publishing

With the ability to design and layout brochures, magazines and books on the computer screen, desktop publishing revolutionized the publishing industry in the 1980s. A basic grid layout is designed, as a master page, on to which text, graphics and photographic elements can be imported. The text can be 'flowed' around the graphical elements, whilst boxes can be drawn and filled with greys, colours or textures. Many desktop publishing programs have powerful imaging facilities within them, particularly for separating the image into its CMYK components (although most bureaux and printers would recommend that they are sent 'RGB TIFF' files, and perform the separations themselves, as they know the characteristics of their output device and the requirements of the separations). Probably the best of these programs are QuarkXpress™ and Aldus Pagemaker™, both of which are available for both Macintosh and PC platforms. Generally, images need to be imported as TIFF or PICT files, usually at low resolution to act as guides for the designer (known as an FPO – 'For Position Only'). When sending material to a printer or bureau for output, it is necessary to leave the FPO in the document, and also include the original picture files so that they can be output correctly by the imagesetter. For example, if you are sending a photographic TIFF file and a piece of artwork saved as an EPS file created in a drawing program, both the original TIFF and EPS files must accompany the document file to the printer.

As well as page layouts, desktop publishing programs are excellent for producing photographer's letterheads and invoices and the like. The letterhead can be saved as a master page on to which letters and other documents are added. This can then all be printed as one document, reducing the need to have large quantities of stationery printed at one time. This can even be done relatively cheaply now in colour, on small desktop colour bubble jet and other types of printer.

Paint programs

Several programs, such as Letraset Painter™ are available where photographic images can be painted over to give the effect of oil paint or various other textures and effects. These are best used in conjunction with a digitizer tablet and pressure sensitive stylus, enabling various amounts of 'paint' to be applied.

Presentation and multimedia programs

Whilst 35 mm slide projectors will survive for a good few years yet, many computer programs are now available enabling photographers and others to produce high class presentations for conferences and seminars and the like. They are much more versatile than the conventional multi-projector presentation as all types of elements from single photographic and graphic images to animations and even video clips can be incorporated into the same presentaion. This can be easily edited on screen, without the need for producing new 35 mm slides, although the information can be output to slide via Slidewriters if required. Video projectors are now extremely high quality (though very expensive!), and remove the need for several slide projectors to be aligned together. Typical programs are Aldus Persuasion™, and Microsoft Power Point™. With these programs, a 'master' slide or template can be made consisting of such items as a background, logo or frames, into which the various elements can be placed.

True multimedia presentations are now relatively easy to produce using programs such as Macromedia Director™. Here, graphics, animation, video, high fidelity sound (including musical instruments via MIDI – musical instrument digital interface) can all be combined into highly complex presentations.

Video editing

Over the last couple of years, huge advances have been made with the handling of video on small desktop computers. Video digitizers are available for most desktop computers, which will digitize video sequences (and their associated sound in some cases) from a variety of sources such as video tape and camcorder. This can be edited on screen using programs such as Adobe Premiere™ which can link sequences together with a huge variety of wipes, fades and other transitions, and mix sound with the video. Some computers and various video boards will convert the digital video to analogue and output it back on to video tape. Video requires huge amounts of storage space. A typical 10 second sequence captured from a colour video with a Video Spigot™ board on a Macintosh takes up nearly 8 Mb of space. As with still images, a number of compression routines are available which reduce the storage space required. Examples are MPEG and Compact Video.

All Macintosh computers have 'QuickTime' software, which is an extension to the system software. It allows the user to play and record dynamic time-based data as opposed to static data such as text and still images. QuickTime incorporates two types of compression – 'temporal' and 'spatial'. Spatial compression reduces information within a single frame by looking for areas of even tone. In an image with a black background, rather than identifying pixel 1 as black, and two as black and three as black etc., it identifies the groupings of black pixels. Temporal compression works by describing

changes between frames – a process known as 'frame differencing'. QuickTime 'movies' can be copied and pasted into other documents, and are being used increasingly for teaching and training applications, where instructions in the form of text can be supplemented with a video clip showing the actual operation of a piece of equipment for example. On PCs, Video for Windows has recently become available, which performs a very similar task.

Morphing

Many advertisements and feature films include sequences where one object gradually merges into another. In the film *Terminator II* a blob of molten metal gradually becomes a human figure, whilst several car advertisements show one style of car merging or 'morphing' into another. Morph™ by Gryphon allows you to select a 'start' image and a 'finish' image. The computer then automatically fills in the middle, gradually merging one into another. A very specialist piece of software!

Using the computer

It is not the intention of this book to be a computer manual – much better advice can be found elsewhere, in some of the books listed in the bibliography. However, good working practices are important, and some of those specific to digital imaging are given here.

1 Always save an image after scanning or digitization *before* commencing any enhancement or manipulation. Most programs have a 'revert' option, enabling you to revert back to the previously saved version of an image. If you have not saved it you will have to start the process all over again.
2 Because images are large, always crop out any redundant information such as unwanted borders, to reduce the file size to a minimum.
3 If you are carrying out complex manipulations or enhancements to an image, save several versions so that you can go back to a particular one. Most current image processing programs on desktop computers only let you undo the *very last operation* carried out. If you are not sure whether a particular manipulation is right or not, then save it with a different file name for reference.
4 Do not work with images that have higher resolution than is necessary. As can be seen in Chapter 4, when the resolution is doubled, the file size increases by a factor of four. If the final output is to be low resolution, or small size, then consider re-sizing the imaging to a lower resolution, in the same way as you would decide what camera/film combination to use for a particular photographic job.

5 Compress images before saving them, using JPEG or some other image compression package, and always keep a second back-up copy on another disk.
6 If you are manipulating images, and perhaps adding new elements, or moving existing elements of an image, be careful to ensure that the result 'looks right' e.g. the lighting direction and quality is the same for all the components used.

Computer hard disks can become corrupted, or damaged in the case of a power failure, often making it impossible to access the data on them. External disk drives such as Syquest™ or DAT drives are excellent devices for backing-up data.

Computer viruses

A virus is a computer program deliberately written to disrupt the normal operation of a computer. They may 'crash' the computer, display messages, delete files or cause other strange things to happen on the screen. They can cause a great amount of damage within a computer, perhaps erasing whole hard disks. Many are designed to come into force on particular days. They can enter a computer via floppy disks, modem links to bulletin boards or through networks. To minimize the risk of viruses getting into your computer system it is essential to take certain precautions:

• Install a virus checker (sometimes known as 'disinfectants') on your computer. Many are freely available from public domain and shareware suppliers, and come into action the instant the computer is switched on, checking all files for viruses. Windows now has a built-in virus checker.
• Do not use floppy disks given to you by other people (particularly with games!) unless you have a virus checker on your machine.
• By their very nature, virus checking programs are always one step behind the authors of viruses, so cannot be relied upon to identify all current viruses.

Health and safety considerations

1 Sit comfortably, preferably in a chair with a good backrest, and adjustable height. You should try to sit upright, and at a height where your forearms are in a horizontal position when using the keyboard.
2 Adjust the monitor height and angle to minimize head and neck movement (European laws now insist that all computer monitors are on tilt-swivel stands). If possible, try to have it at such an angle that you are looking down at the monitor slightly. Do not sit too close to the monitor.

3 Place the monitor sideways to windows, thus avoiding reflections on the screen.
4 Take frequent breaks from the computer. Walk away from the computer to get some exercise and rest your eyes as much as possible.

7 PhotoCD

The main reasons for devoting a whole chapter to Kodak's PhotoCD storage system is first that it offers the cheapest method of scanning images currently available. For a relatively small outlay, a roll of film can be transferred to consumer PhotoCD. This can establish whether or not a system using photographic images will work on a given computer platform. The format is also supported by all the leading players in the computer and film marketplace and looks like becoming an industrial standard for image recording. The other main factor in its favour is that image files are large and storage is a problem. Typically, CDs can hold 600 Mb of information, making them ideal for photographic archiving.

The photo imaging workstation

PhotoCD disks are created on a Photo Imaging Workstation or PIW. These units represent a substantial investment in equipment and will only be found in environments such as imaging bureaux, large institutions, image libraries or publishing houses. The major factor in the cost of such units is the intensive computing power required and the need for very high speed film scanners. These units can be regarded as factories for the production of PhotoCDs and as such require large numbers of images to be scanned and written to disk to justify their existence.

The medium

A PhotoCD consists of two components

1 The disk: A CD disk playable in Apple Macintosh and IBM PC machines and also viewable on a domestic television using a PhotoCD or CDI player

Table 7.1 Image pack quality

Resolution	Dimensions	Size	Usage
Base/16	128 x 192 pixels	72k	Thumbnail for database
Base/4	256 x 384 pixels	288k	low resolution image for placement in DTP programs
Base	512 x 768 pixels	1.1Mb	Television quality
4Base	1024 x 1536 pixels	4.5Mb	HDTV quality
16Base	2048 x 3072 pixels	18Mb	Publication quality scan

2 The Image Packs: On this disk each image is recorded at five different resolutions or qualities of picture.

The combination of the image pack on a CD disk is termed PhotoCD.

The Standard PhotoCD is made from any type of 35 mm film, slide, negative or black and white. Each disk can have a combination of any of the three types of film. The consumer service is offered by the majority of film developing outlets and subsequent films can be added to the disk at later dates to a maximum of 100 images per disk.

Pro PhotoCD

The launch of PhotoCD was followed by Pro PhotoCD. The main difference between the two systems is the Pro disk can scan larger formats than 35 mm. A bureau will charge more than the consumer services but they provide far more in terms of control over the image scan and of course provide a much quicker service. The Pro disk is produced by a professional bureau and the service offered can be regarded as the difference between having your film processed at a high street chemist or a professional photographic laboratory.

PhotoCD structure

A CD disk is a 4¾″disk of polycarbonate plastic with an ultra thin layer of gold bonded to the top surface of the disk. A protective surface is then coated on to the gold layer for protection. The PhotoCD is produced by burning a series of pits into a dye layer on the underside of the gold layer, writing from the inside of the disk out towards the edge (Figure 7.1). This information is

Figure 7.1 Photo CD image pack.

then read by a laser diode in the CD drive and converted into image information.

The PhotoCD stores all images in a YCC format. The Photo imaging workstation scans the film and produces the top resolution image. This file is duplicated and the copy examined and every alternate pixel of information is discarded to produce a file half the height and half the width: therefore one quarter the resolution. This process is repeated four times.

The workstation holds the five images in its memory. It then records the three lowest (base/16, base/4, Base) as normal files and subsequently interpolates (invents) a 4 Base image from the base resolution and compares it with the real 4 Base image. Where the data of the two images match the workstation does nothing, but where the interpolated file is incorrect it saves the information from the real file. It repeats this process with the 16Base image and saves only the difference between the real and invented file (residuals). By this method 24 megabytes of information can be reduced to some 5 megabytes.

YCC colourspace

The YCC colourspace is a mathematical description of a colour. The colour is described by three values, one for Luminance (brightness) and two for Chrominance (colour). The advantages of this system are:

1 it allows high levels of lossless compression of the image;
2 it provides a system that provides consistent representation of images from negative or positive originals;
3 it provides the widest gamut of colour space in which to store colour information.

Physical file structure

On opening a PhotoCD disk the information is divided into two directories (Figure 7.2). The disk itself will be called after the individual number which is printed on the centre of the disk. The first directory is called CDI, and this contains all the relevant information to play the disk on any Philips CDI compatible system. The second directory is called PhotoCD and within this directory reside several files pertaining to the images.

1 INFO.PCD:1 A file with global information about the disk including its creation date, last update and serial number.
2 OPTIONS.PCD:1 The type of disk.
3 OVERVIEW.PCD:1 The assembled contact sheet used to print the cover of the disk.
4 STARTUP.PCD:1 The PhotoCD logo shown at the start of all viewing sessions on a player and a further sub-directory IMAGES containing the image packs for each image.

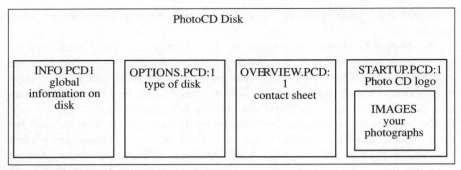

Figure 7.2 *Diagram of PhotoCD structure.*

Apple PhotoCD access

On the Apple Macintosh platform an extension is available with the Apple CD 300 software which works in conjunction with Quicktime. This extension creates three virtual directories which appear to be on the PhotoCD Disk. In fact these files reside in the memory of the computer.

1 SLIDE SHOW: this is a Quicktime movie of all the images on the disk.
2 SLIDE SHOW VIEWER: the application that runs the show.
3 A sub-directory called PHOTOS with five sub-directories, one for each of the image sizes in the image pack. All images in these folders are represented by tiny thumbnail images. Clicking on a thumbnail will result in the Quicktime software generating a PICT file of the image at the specified resolution from the information in the image pack.

The Pro PhotoCD system also offers the option of a higher quality resolution (64Base) added to the image pack. This will however limit the images on the disk to 30.

 The reason behind the differing sizes of image is that all access software makes the assumption that the image size is 35 mm therefore any image not in the 35 mm : 24 mm format is packed with blank pixels. Table 7.1 shows the information content of the unpacked image.

Table 7.2 Pro PhotoCD formats

Format	16Base pixels	64Base pixels
35 mm	2035 x 3072	4096 x 6144
6 x 4.5	2035 x 1536	4096 x 3072
6 x 6	2035 x 2048	4096 x 4092
6 x 7	2035 x 2390	4096 x 4780
6 x 9	2035 x 3072	4096 x 6144
5 x 4	2035 x 2615	4096 x 5230

The major advantage of the professional service is the control you can have over the scanning process, but in order to exercise this control an explanation of the technology is necessary.

Photographic control

The first issue to be addressed is the exposure of the film. Wherever possible the exposure should be controlled to give a density range of *no greater than* 2.8. This applies to any scanning process utilizing CCD technology including drum scanners. The object lesson here is that although supersaturated transparencies look wonderful on the art directors light box they cannot be reproduced successfully in print.

Control the density range

Control over density range can be achieved in the studio by strict control of the highlight to shadow ratio. This is a process of reducing contrast by lightening areas of shadow. On location similar effects can be made by use of fill-in flash to lighten shadows in subjects close to the camera.

In situations where no control is possible it is recommended that the option of colour negative film is used rather than transparency film. Colour negative film normally exposed and processed gives a lower density range making it an ideal film type for the reprographic process.

Colour matching

The person controlling the scanner has two choices when controlling the colour of the scan:

1 they can match the colour to the original scene (specific film term);
2 they can match the colour to the colour on the film (universal film term).

At first glance this statement sounds like a contradiction. The first option will utilize a specific film term for the type of film and compensate for any colour bias in that type of film. For example some films show a bias towards green and this would be corrected to give a neutral cast in the resulting scan. This process is know as 'scene balancing' and can prove useful in situations where no control is possible at the time of exposure. The second option would give a exact replica of the film resulting in a digital Kodachrome or digital Ektachrome with the same characteristics as the film stock.

Film term summary

If two separate exposures of a single scene are made on different types of film specific film term scans will produce very similar results. Universal film

term scan will preserve the subtle difference normally observed in the films themselves. Specific film terms use a system called Scene Balance Algorithm (SBA) to adjust the image. Parallels can be drawn to an auto-exposure photographic printing system which assumes an image will integrate to a certain percentage grey and a hand print which the operator adjusts for each image. In the same way low key or high key images will fool the auto-printing system, they will also suffer detrimentally at the hands of the SBA system.

The operator of a professional bureau can also remove a colour cast caused by other reasons if required to do so.

Checklist for submitting films to a bureau

- Scan pric for roll film is less if unmounted and uncut.
- Label each film.
- Specify if universal or scene balancing terms are to be used.
- Specify if 64Base is required.
- Specify any colour correction to be made.

Choosing resolution

The first question to consider is that given six possible image sizes which should be used for printing? The answer is dependent on the size of the image to be printed. The conversion process involved is between pixels on the monitor and ink dots on the page. Printing processes use a system of halftones to produce photographic images on the printed page. Different qualities of halftone are used depending on the type of paper to be used for printing. A general rule of thumb is that four pixels of information translate into a single halftone dot.

Using this rule, the 16Base image will produce an image of about 10" x 7" using a screen ruling of 150 lines per inch.

Working out image size

Dimensions of Image x Halftone Screen x 2= number of pixels. For example, for a 5 x 4 inch image at 150 lpi:

5 x 150 x 2 = 1200 pixels
4 x 150 x 2 = 1500 pixels

therefore the required image should be 1200 x 1500 pixels.

On the PhotoCD there are two qualities or resolutions close to this value:

4Base	1024 x 1536 pixels	4.5 Mb
16Base	2048 x 3072 pixels	18 Mb.

Therefore if the 4Base is used it lacks some of the information and if the 16Base is used some of the information will have to be discarded. In practice it has been found that no noticeable difference in quality is discernible until the ratio of information recorded on the halftone is one and a half times rather than twice the pixel size as the formula suggests. So the minimum file size would be

5 x 150 x 1.5 = 900 pixels
4 x 150 x 1.5 = 1125 pixels

The obvious advantage gained by using the smaller of the two images is to reduce the size of the files needed to produce the page. So a trade in image quality for a more portable document would prove a positive advantage.

An alternative is to use a larger file to retouch and reduce the image size when placing it in the document, this will hide any signs of retouching in a similar way that conventional retoucher's will work on a 10" x 8" film and reduce it to 5" x 4" to hide their handiwork.

PhotoCD compatible drives

The PhotoCD format was not readable by the first type of CD drives available; since that time all new drives have had PhotoCD compatibility built into their operating systems. On the first implementation of PhotoCD compatibility only single session type systems were available.

The two main types of disk are single session or multisession, but portfolio and catalogue disks are also available and these four types are considered below.

Single session

This refers to a disk that is written at a single sitting. All the images are added to a single continuous stream of data.

Multisession

This refers to a disk which has images added at different times. Images can be added to an existing disk if there is enough free space. There are some computer CD drives which are not XA(multisession) compatible. If only the first images on the disk are accessible the reason is probably that the drive is single session.

Portfolio

This disk combines the lowest three image pack resolutions with sound and graphics to give a multimedia inactive disk. A typical use is the travel

industry where a potential customer could pick from a menu of locations and see hotel rooms, scenic photographs and hear a commentary on the holiday of their choice.

Catalogue

This disk holds just the low resolution images and via database software on the disk would allow the potential customer to photographic library to display images on any given subject with the option to contact the library and purchase the use of higher quality images.

8　Output

Obviously the capture and manipulation of digital images is of little use without a method of producing printed output. The difficulty in describing output devices is the historical background to the technology involved in computer printers. Until fairly recent times very few computers were capable of producing anything like a photographic image. Their main use was in word processing, consequently the printers were designed with the production of black and white text in mind. Colour printers were designed in the main for the production of graphic type images and the only photographic quality printers were designed for military satellite image production.

Graphic file formats for printers

There are two common methods of representing an image in the computer environment, bitmapped files and PostScript descriptions. Most printing devices are designed to print one or the other type of image.

Bitmapped images (TIFF, PICT, TARGA, etc.)

In a bitmapped image the elements of the picture are mapped as individual screen display pixels. The image is stored in an array of binary information. Each pixel of the picture is represented by one bit or binary piece of information. (In the case of a greyscale bitmap each pixel requires 8 bits which can represent 256 levels of grey.) Magnification of a bitmapped image will show the pixel elements in its construction.

PostScript files

PostScript is an interpreter between computers and output devices. The PostScript file translates the picture into a series of PostScript graphic drawing routines with a degree of resolution much finer than can be represented on the screen of the computer. For example an image of a house could be represented by a square with a triangle on top. In the PostScript system enlarging this image would only create a larger square and triangle. The bitmapped image would break down into the dots forming the lines of the square and triangle.

PostScript cannot record photographic images; however it can handle text and graphic elements with great effectiveness. In a PostScript file photographic elements are saved as bitmaps. The system is slower to print these pictures than a dedicated bitmap printer. Bitmap printers will print photographic

elements faster and better than a PostScript printer, however the quality of text and graphic elements will not be as high.

The PostScript version of a printing system will normally cost more as a licence fee is payable to Adobe, the authors of the technology. The printing of continuous tone (photographic) images varies depending on the technology used and the quality of the output is very dependent on its production method. In order to understand the shortcomings or advantages of the various methods an explanation is necessary of the methods they use to emulate continuous tone.

Continuous tone reproduction

In a photographic image colour is generated by having three layers of dye, each layer corresponding to one of the primary colours of red, blue and green. The silver halides in these layers are converted into microscopic dye clouds and due to the fact that each layer is transparent a full spectrum of colours can be reproduced. The colour is controlled by increasing the density of the dye to increase the saturation of the colour.

The halftone image (lithographic or photogravure)

This is a method of representing the images as a range of tones from white to black using only the medium of black ink. The white tones could be represented by the white of the paper and the black by areas of solid ink, but the remaining tones would have no way of printing. The solution to the problem is to introduce the concept of 'screening' the image. That is to convert the various densities of the image into small dots of the same density (black ink) but which vary in area; the minimum density of the image (the white) is represented by very small dots which will increase in size as the density of the image increases. The obvious solution would be to print the white with no dots and the black with 100% dots.

Creation of screen dots

The negative of the required image is exposed to a positive material in contact with a fine mesh or screen. Diffraction and penumbra effects mean that the image forms vignetted circles of light under the screen which increase in size in proportion to the intensity of the light.

Smallest unit of image structure

The size of the smallest unit of image structure is considered as the density of the screen; that is to say that with an 85 lines per inch screen there are 85 lines on the screen and 84 possible dots per inch. *Note*: The dots can be any size

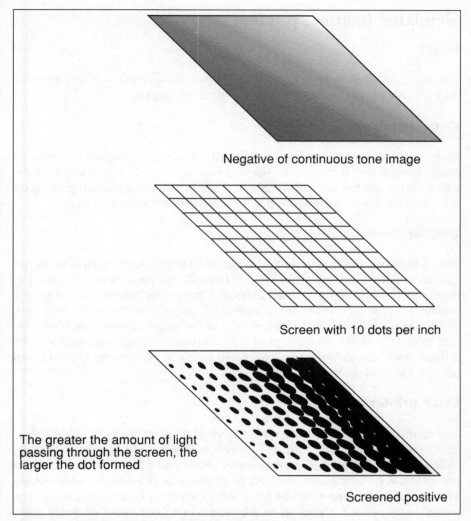

Negative of continuous tone image

Screen with 10 dots per inch

The greater the amount of light passing through the screen, the larger the dot formed

Screened positive

Figure 8.1 *Halftone. The greater the amount of light passing through the screen the larger the dot formed.*

from barely visible to a maximum of 1/84 of an inch. For colour images it should be possible to re-create the image using three screens, one for each of the secondary colours of cyan, magenta and yellow (CMY) in the image. However, due to deficiencies in ink technology it is not possible to print a true black from these three colours, only a brownish black occurs, so a fourth separation is made for the black (referred to as 'K'). The control of colour saturation is thus achieved using the size of dot forming the image (Figure 8.1). Neither of these methods is available in an output device as a computer printer.

Simulated halftone printers

Inkjet

The cheapest form of computer printer is the inkjet. There are two forms of inkjet technology: continuous flow and drop on demand.

Continuous flow

Using this method the printer continuously directs ink droplets towards the paper surface and if the ink is required by the image it is deposited on the paper and if not the ink is deflected to a waste tray. This method gives good ink coverage but is wasteful of ink and therefore expensive to run.

Drop on demand

This system produces ink only when required by the image. Both systems use heat to vaporize the ink and propel it towards the paper through a nozzle. As the ink heats it forms a small bubble at the end of the nozzle, hence the common name of bubble jet printers. All inkjet printers work best with dedicated paper types as the absorbency of the paper controls the brightness and definition of the image (Figure 8.2). Greyscale images are produced by a black ink cartridge and colour by a two cartridge system one for black and one for cyan, magenta and yellow.

Laser printers

The majority of laser printers are black and white printing devices, but colour lasers are now becoming available, although they tend to be very expensive.

The printer contains a rotating metal drum coated with a fine layer of photosensitive material. An electrostatic charge is applied to the whole drum. The charge on the drum can be removed by applying light to its surface. The image to be printed is applied to the drum via a laser beam or diode laser. A negative image of the subject to be printed is projected on to the surface of the drum. The result of this is to 'undraw' the image on the drum as it rotates. This process is similar to producing a statue by removing all the pieces of stone that do not look like the subject. The end result is to leave an image of the original in electrostatic charge on the drum. The drum rotates past a toner dispenser containing ink. The ink used has an electrical charge and is attracted to the charged image on the drum. This can then be transferred on to paper by giving the paper the opposite electrical charge so that the ink is attracted from the drum on to the paper, giving a black ink image on the paper. The light source scans across the surface of the drum forming the image by a series of overlapping individual dots. The minimum size of the dot is the width of the light beam as it is focused on the drum. This means

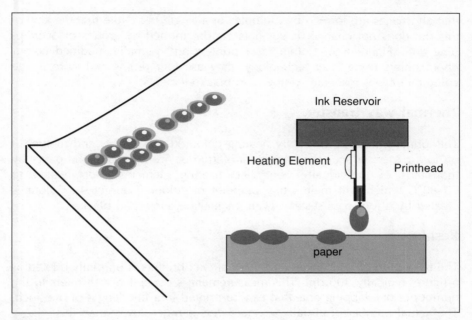

Figure 8.2 *Inkjet.*

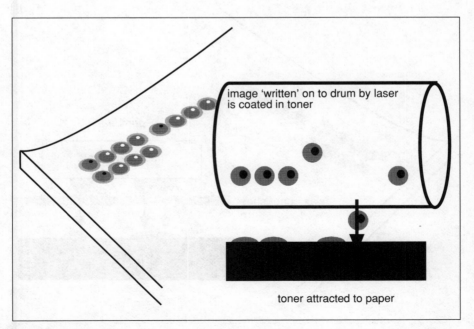

Figure 8.3 *Laser drum.*

that all images are formed by multiples of a single dot. Note that the size of this dot does not change, larger dots can be formed by groups of overlapping dots (Figure 8.3). Colour laser printers are normally modified colour photocopiers using laser technology, they use four drums and store image colours in cyan, magenta, yellow and black elements.

Thermal wax transfer

This printing method works by heating coloured wax sheets and melting it on to a paper surface. The wax is transferred or 'ironed' on to the paper by thousands of individually controlled heating elements each heated to 70–80°C which will melt a tiny pinpoint of colour (Figure 8.4). Colour is created by a four pass system: cyan, magenta, yellow and black.

Resolution

The resolution of laser inkjet and thermal wax printers is normally quoted as a figure, typically 300 dpi. This measurement is deceptive as it refers to the number of overlapping dots that can be printed in a line length of one inch. The actual number of visually separate dots is much lower than this.

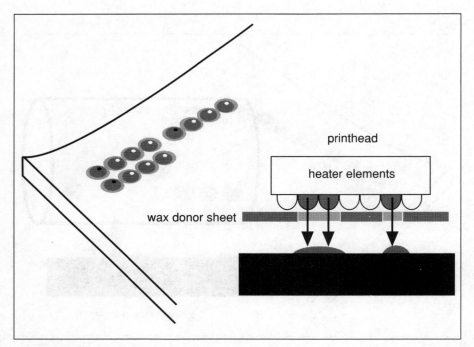

Figure 8.4 Waxtransfer system.

The design of printers is based on their role as producers of high quality text. Text can be considered as individual items of line art. Therefore a higher scanning rate and a greater overlap of scan mean that the continuity of the line is more assured. Laser, inkjet and thermal wax printers all use opaque colour so the photographic formation of colours is not applicable. Their mode of operation also means that they are only capable of forming a single dot size so a true halftone technique is also unavailable. The solution to this problem is to introduce simulated halftone representation or dithering. This should not be confused with halftoning in its more established form. In its simplest form representative halftone is a method of representing greyscale.

The representative halftone

The image is considered as a two dimensional array of pixels. Each pixel contains the value of tone from black to white. By grouping these pixels into blocks of 4 x 4, then averaging the values of all 16 a coarser representation of the image is created. The tones forming the image are separated into 16 thresholds or levels. Level 0 represents white, level 7 represents a 50% grey, level 15 represents black, etc. The next operation is to replace each level

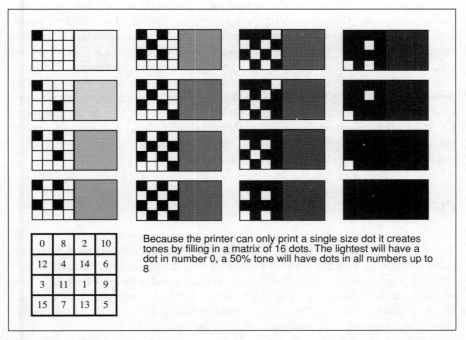

0	8	2	10
12	4	14	6
3	11	1	9
15	7	13	5

Because the printer can only print a single size dot it creates tones by filling in a matrix of 16 dots. The lightest will have a dot in number 0, a 50% tone will have dots in all numbers up to 8

Figure 8.5 *Dither pattern.*

with a dot pattern that bears a direct relationship to the tone (Figure 8.5). The arrangement of the dots in the 4 x 4 block can be changed. There are a number of patterns, a standard pattern, bayer, spiral, line, etc. The method of forming the values is the same but the position of the numbers in the cells changes.

In Figure 8.5 each cell in the matrix corresponds to one of the 16 tones from 0–16. The numbers can be considered as levels of grey in the original image. Each level is represented by a pixel in its cell and a pixel in all the cells lower than itself. For example level 8 will have pixels in all the cells from 0–8. This gives a rough approximation of the small to large dot sizes in true halftoning. The standard halftone shows a full range of all the cell patterns from white to black on the left and, on the right, a block of the pattern as it will appear on the screen.

Colour dithering

By a similar dithering pattern, using the cyan, magenta and yellow colours, a representation of all other colours can be achieved.

Thermal dye sublimation printer

This system of printing uses a system of transferring a dye from magenta, yellow and cyan ribbon on to a paper surface. The heating element vaporizes the dye on the donor ribbon surface which is then absorbed into the surface of the paper (Figure 8.6). As this dye is transparent each pixel on the page can represent any colour by varying the amount of the three colours. The action of the dye as it is absorbed into the paper also means that the individual pixels join together to form a seamless area of colour similar to a true photographic print. Many printers of this type are in use by photographers of all types, social, medical and commercial, as direct replacements for photographic prints. Their main drawback is the limitation in size – usually A4, although A3 models are available.

Pictrography

This system uses laser technology to beam the image on to a chemically impregnated donor sheet inside the machine. Red, green and blue lasers are used to form the image on the surface of the donor material which is then brought into contact with the paper surface and heated. The activating element in the system is a small amount of distilled water which is removed by the heating process. The donor sheet remains in the case of the printer and as the process uses a silver halide based system the silver can be recovered from the donor sheets.

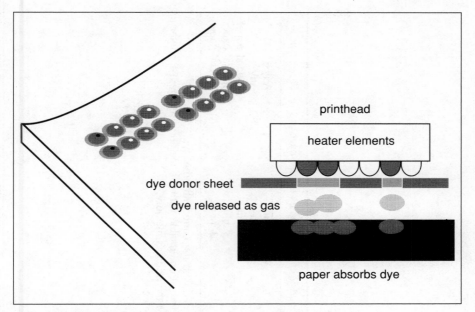

Figure 8.6 *Thermal dye sublimation.*

Printing to film

The option also remains to print the image on film and there are two systems to achieve this end.

Analogue film recorders

This system uses a cathode ray tube (CRT) on which the image is formed. Three successive exposures are made by a camera system, one for each of the three primary colours. This system can be regarded as the automated version of photographing the computer monitor in a darkroom using a conventional camera system. Resolution is always dictated by the resolution of the CRT display. Normally using 35 mm film, this type of recorder is primarily aimed at the corporate presentation market.

Digital film recorders

This system uses laser or light valve technology to 'draw' the image on to the surface of the film. The resolution can be increased by control of the dot forming the image and the number of pixels it draws to form the image. The system is designed to re-create 10″ x 8″ transparencies from images retouched on high end systems.

Table 8.1 Printer comparisons

Printer type	Cost of printer	Resolution	Visual appearance	Print speed per page	Paper type
Inkjet	Low	300 dpi	Low	1 min	Any●
Laser	Medium	300 dpi	Low	20 sec	Any
Thermal wax	Medium	300 dpi	Medium	3 min	Special paper
Thermal dye	High	300 dpi	High	3 min	Special paper
Pictrography	High	300 dpi	High	3 min	Special paper

●Although any paper may be used the printer performs best with paper designed with the correct absorbency.
The first copy of an image requires interpretation of the computer file into a format compatible with the method used by the printer to print colour, subsequent prints require shorter times as the last print is held in the printer's memory.
Maximum paper size refers to the largest machines available using the technology.

9 Getting to the printed page

Transferring an image from computer screen to the printed page is an area of digital imaging which causes much controversy amongst photographers and printers. In order to describe the problems involved an explanation of the stages and the controls at each stage must be given.

The photographic process

Photographic film will record a *representative* image of the subject. In the majority of cases the photographer will make a visual assessment of the image and subject and assess its suitability. Specialized subjects such as scientific processes, medical photography, paint or fabric samples have more objective controls. For general photography however, assessment is usually in terms of subjective parameters.

Photographic priorities

1 Sharpness.
2 Exposure of the film (does the film show the required (subjective) tonal range: highlight detail, shadow detail?).
3 Lighting (does the image show a colour cast?).
4 Development (is the image on the film free from development defects?).

Until now many other features of the image have not been a major concern to the photographer but with the increasing use of digital imaging these other issues must be addressed. The final stage in the process for the photographer was delivery of the transparency to the client. The client then delivered the films to another party to print. Any communication between printer and photographer proved difficult. New imaging technology has cut out many of the intervening steps in the process and photographers will increasingly require more of an understanding of other areas of reprographics.

Colour gamut

This is the range of colours that the final output form of the image can display. This can be anything from a magazine or newspaper page or a computer monitor or television display.

Each device or printing process will display a limited number of colours compared with the original subject. No printing process can show an exact

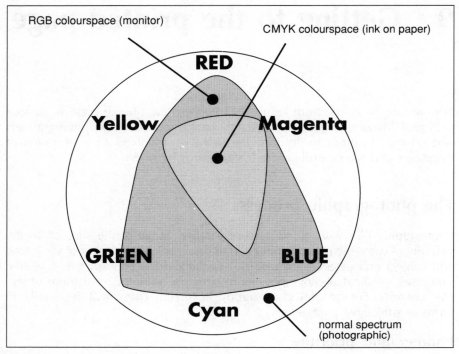

Figure 9.1 Colour breadth of devices.

copy of an original subject – what printers aim for is the best possible representation. This is obviously subjective, in much the same way that some photographers may prefer the colours and contrast of Fuji as opposed to Kodak films for example.

It can be seen from Figure 9.1 that the range of colours decreases as we approach the printed page. It is therefore important that the colours are translated in a way that will give the most accurate representation possible. To achieve this aim a system called 'colour space' is used.

Colourspace

Several different systems of colourspace are available but they all work on the same principle. The colourspace is an independent language that describes each colour. It should be capable of describing all possible colours regardless of a device's ability to record them.

The image colours of a scanner, camera, film, etc. are translated using device profiles into the realm of the colour space. They can then be remapped into the output gamut range using the particular device profile for the printer, monitors, etc. (see Figure 9.2).

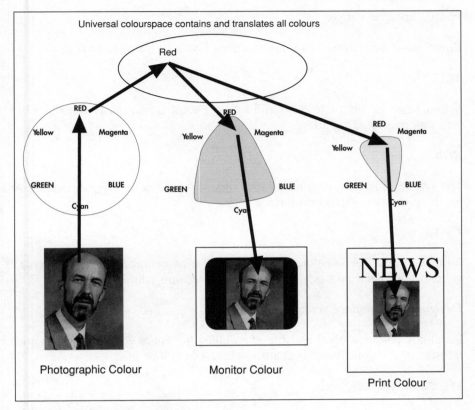

Figure 9.2 *Colourspace system.*

It can be seen from Figure 9.2 that in order for the system to operate the colour space requires three elements:

1 profile of the input device;
2 compatibility with the computer platform on which programs run;
3 profile of output device.

Several colour space systems can also work together by translating between colour space. The system of colour space has been established in the print industry for a number of years. Systems such as Focalcolor, Pantone, etc. have been used successfully by designers to describe colour tones to printers.

Colourspace systems

Visible spectrum

The range of colour visible in the real world by the Human eye.

Photographic dye

Constructed by yellow, cyan and magenta layers of transparent dye.

YCC

System used for both television and Kodak PhotoCD. Colour is described by hue saturation and lightness.

RGB

The system used by computers, each colour being described by a number of levels of the red, green and blue.

CMYK

Printing colours: each colour is described by a percentage of cyan, magenta, yellow, and black inks (K not B to avoid confusion with blue).

Designed colourspace (computers)

Imaginary colour systems capable of handling the entire visible spectrum and translating a colour into the nearest achievable colour of another system.

EFI, ColorSync CIE, etc.

These systems work by a process of input profiles of the input device which describe its response to the spectrum. The screen is then calibrated using a light sensitive device to ensure a consistent response to all colours. The output device's profile is chosen and the screen can give a simulation of the possible change in colour. The option is then to translate the colours to give a more constant response to the restriction of the gamut of the output.

Designed colourspace (graphic design)

This is a matching system for the graphic designer. Colours are based on a numbered system and the designer chooses from a book of printed samples. A removable sample swatch of the colour or colours can be attached to the artwork. The printer can then make reference to charts of ink, mixing them to render the exact colour. The system works on the principle that the samples are printed on to the same type of paper and have the same finishing techniques applied to them as the required colour. Examples of this swatch system include Pantone, Focaltone and Trumatch. The major disadvantage of all these systems is that they all relate to the CMYK colour space. This space has a smaller gamut than the photographic input and therefore it works best with graphic images.

Colour measurement

In order to assess the accuracy of a colour, measuring devices must be used. These fall into four groups depending on the area of colour which is being assessed.

Colour temperature meter

This is a photographic tool used to assess the light illuminating the subject. Since film is normally balanced for either daylight or tungsten, modification of the image can be achieved by applying appropriate gelatin filters in front of the lens to give a 'correct' colour.

Colour densitometer

This will measure the proportion of cyan, magenta and yellow light transmitted by the film as optical densities.

Reflection densitometer

This will measure the proportion of cyan, magenta and yellow light reflected by a colour in the case of a photographic print or printed sample.

Tristimulus reflection colorimeter

This will measure the attributes of hue, luminance and chroma of a colour. It can give a more critical appraisal in trying to create exact colour matching.

Colour proofing

This is the most contentious area of desktop publishing. The process of creating a colour facsimile for approval by the client has long been an established practice in the publishing world. There are several classifications of proof and various methods of production.

Positionals, position proof, composite, for position only (FPO), black and white comps

These are representations of the elements which comprise the page. They show the structure only and no attempt is made to give colour accuracy.

Soft proof or on screen preview

This is the page as represented on the computer monitor. The colour, contrast and resolution are limited by the calibration and construction of the monitor.

Always bear in mind that the monitor display is composed of glowing phosphorescent dots, whilst printed output is composed of ink or dye on paper. Also, try to achieve a constant viewing condition for the monitor. In the same way that proof colour prints should be viewed under a standardised light source, so should computer monitors.

Typical position proof devices

1 thermal wax printers;
2 low cost inkjets;
3 laser printers;
4 colour photocopiers.

Digital proof or colour comp

This is an attempt to represent the page content and colour using a technology other than the ink on paper process. The danger here is that the gamut of the two output devices differs substantially. The process can give a good result if the image is modified by a colour space system to represent the limitations of the CMYK colour space of the final published result. This manipulation of the image requires a skilled operator who is aware of the input and output profiles of the input device and target device as well as intervening processes that will affect colour. The major drawback of this type of proof is that the actual structure of the image will differ from the printed page.

Typical 'digital proof' devices

1 High end inkjets (Iris, etc.);
2 Dye sublimation printers.

Contact proof or separation based proof

This will attempt to simulate the actual dot structure, dot gain and colour of the final printed page. This is more accurate but expensive. The four separations are either created as four separate sheets on clear film and viewed together in a register termed an overlay proof or alternately the four colours are created on layer material and laminated on to a single sheet termed a laminated proof.

Typical contact proof systems

1 Matchprint from 3M;
2 Cromalin from Du Pont;
3 Fuji Colour-Arts;
4 Kodak approval system.

Press proof or press check

The final, and most expensive form of proof, is a page printed using ink from the actual plates that will print the page. The process of making the page is complete and this is a last check. Any correction done after this stage will be very expensive as the plates will have to be remade.

Colour pathway

During its translation to the printed page an image has to go through a series of translations from colour space and media. A photographic image is stored on a piece of film containing a silver halide emulsion. The colours are recorded by three layers each sensitive to a different wavelength of light.

- A blue sensitive layer containing yellow dye.
- A green sensitive layer containing magenta dye.
- A red sensitive layer containing cyan dye.

All the layers are transparent and the density of the dye is proportional to the intensity of colour.

- To represent black all three layers have full saturation.
- To represent white no dye is present.
- To represent a primary colour two secondary layers have full saturation (i.e. to represent red, magenta and yellow are fully saturated).
- To represent a secondary colour just one layer is saturated (i.e. to represent cyan just the cyan layer is saturated).

The image must then be scanned into the computer where it may be viewed on a monitor and translated into the RGB colour space.

There are two separate issues at this stage of the translation. The first is the translation of the image to a digital form. Each of the smallest composite parts (pixels) of the image is divided into three channels red, blue and green, the intensity of which is represented by a numerical value between 0 and 255. The best way to think of this is to imagine that the value zero switches on that channel and 255 switches it off. So if all colours are switched off black is produced as follows:

- To represent black, the red, blue and green channels all have a value of zero.
- To represent white, the red, blue and green channels all have a value of 255.
- To represent a primary colour just that channel has a value of zero (i.e. to represent red, the red channel has a value of zero). To represent a secondary colour two primary channels have a value of zero (i.e. to represent yellow, red and green channels have a value of zero).

The next consideration is the method by which colour monitors operate. The monitor projects three tiny dots of red, blue and green light. These dots

are so small that the human eye integrates the three colours into a single point.

- If no dots are projected the screen appears black.
- If all three dots are projected the screen appears white.
- If just the red dots are projected the screen appears red.
- If red and green dots are projected the screen appears yellow.

The main limitation of this system is that black is only the normal colour of the screen when switched off. Therefore the appearance of contrast can be deceptive.

The next stage is the translation into the CMYK colour space.

Note: CMYK images cannot be viewed on computer systems. Any attempt to view a CMYK image will result in the computer making a translation into RGB to display the image.

The RGB image is translated into four channels: cyan, yellow magenta and black.

- To represent black, the black channel has value of 255.
- To represent white, all channels have a value of zero.
- To represent a secondary colour, just that channel has a value of 255 (i.e. to represent cyan, the cyan channel has a value of 255).
- To represent a primary colour, two channels have a value of 255 (i.e. to represent red, yellow and magenta channels have a value of 255).

Print on the page (four-colour printing)

A printing press is not able to print shades of colour in the way that a monitor can show different levels. It can only print one of four opaque colours. In order to simulate the various shades of colour it uses the principal of halftone. This method of simulation of shades of colour is acceptable to the human eye. Close examination of a monochrome printed page will reveal that the image is formed of dots. The intensity of the tone will result in larger dots, white having the smallest or no dot and black the largest size of dot. Patterns of cyan, yellow, magenta and black dots give the impression of all the other colours and tones. Black is needed as the combination of cyan, magenta and yellow ink fails to give a true black.

The technology of desktop digital imaging is still in its infancy compared with film. A universal colour management system has yet to be established but all the major manufacturers are co-operating in researching the subject and it should not be too long before a single system for producing predictable colour output is available.

10 Communications

We are constantly being told that the telecommunications revolution is here. Companies are busy installing fibre optic and other types of cable to give us more and more television channels, and greater choice with our telephones. Video phones and video conferencing are now a reality, enabling face to face meetings, or participation in conferences thousands of miles away. For photographers, this revolution will mean the transmission of images much faster and more easily than ever before. Systems like Kodak's Picture Exchange will give publishers in London, for example, the ability to view images on their computer screens from stock libraries around the world.

The last true sanctuary of computer doublespeak, electronic communication is populated with a jargon incomprehensible to the non-initiated. Perhaps the best way to approach the subject is to break it down by the objectives in the process.

Suppose that there is an image on a computer somewhere in one country and it is required on a receiving computer in another country. Several factors are involved in obtaining it, including time, cost and technology.

Time is money

Since telephone time costs money and the transmission takes time, it makes sense to compress the file before sending it. The most common form of image compression is JPEG, used widely by photographers, and an integral part of many image manipulation programs such as Adobe Photoshop.

A common language

What language does the receiving system speak. Are the two computers running the same operating system? If not a common file format for both must be established.

Software for sending images

These programs are known as terminal emulators (relating back to a time when communication systems used a dedicated workstation, called a terminal, with no computing power). They allow the user to choose a file, input the receiving computers phone number, then monitor the line and wait for the distance end to answer. On connecting the two computers the file will then be sent.

Most of these programs support scripting languages, i.e. they have the ability to record a number of commonly used phone numbers, or to wait until a cheaper time to call before sending a number of stored images.

Connecting to the phone

Telephone lines were designed to transmit voices. Their design parameters will only transmit the minimum acceptable frequencies to reproduce vocal communication. Also over long distances the phone companies use techniques to send a number of calls over a single connection.

There are many methods of transferring information between computers utilizing built-in or added networking systems such as Local talk and Ethernet.

The restrictions of using a telephone network mean that the signals between the two machines have to be converted into something approximating the human voice. The device which carries out this process is known as a 'modem' (modulator/demodulator). The modem can also 'speak' the tone or pulse system used to dial the call. Since the image data have been translated into a different language, a second unit will be needed to translate the data back into a form understandable by the receiving computer. When buying a modem the cost is directly proportional to the speed that the image is sent. The faster the speed the higher the price. Speed is quoted by the term 'baud', or bits/sec. The common form of description for computer data is the byte, as in a 720 K capacity floppy disk, which can store 720 000 bytes of information. The modem environment seems to be the only area where the term bit is still in use (probably because it makes the numbers larger from a sales point of view!). There are eight bits to a byte so caution must be exercised when estimating transmission times. For example: to send a 1 million bit image over a system using 1200 bits per second would take 1 000 000/1200 = 833 secs = 13 mins. However to send a 1 Mb file would be eight times this =104 mins. In reality it would take even longer than this as the system is also sends data to check on and communicate between the two modems.

The phone network

There are a number of modems which offer faster speeds. However the important thing to remember is that you can only transmit as fast as the receiving modem. Modems with speeds of up to 14.4 Kbps are available but modem speed can be dramatically reduced by the poor quality phone lines.

Software at the destinations

The data being sent to the receiving computer is checked as it arrives and the electronic equivalent of a 'OK so far' is sent back. Any faulty data will cause the system to ask for it to be sent again.

Sending computer and modem

Telecom network

Receiving computer and modem

Figure 10.1 *Connection.*

The following sections discuss several further points to consider in the selection and use of modems.

The transmission software

Most modems come with software but they may not be the most user friendly. In general the more you pay for communications software the less you have to do. The software will work out most of the technical issues itself.

With modems and modem software the user configurable controls can be terrifying. This is not for the faint hearted or the random button pusher so a list of the possible options, explanations and the normal defaults is given below:

The file format

The best format for both the PC and Macintosh platform for bitmapped images is TIFF. Further details of this and other image file formats can be found in Chapter 6 on image processing.

The modem

The standard for all modems is 'Hayes-compatible', a brand name which has become synonymous with the product. A non-Hayes-compatible modem will not communicate with the majority of other systems. Two points worth looking for are status lights that keep you informed as to the progress of the transmission, and the ability to switch on a speaker and listen to the progress

of the call so you can hear things like lack of dial tone, cross lines and ringing tone.

Baud rate

The standard speed used by most systems is either 9600 bps or 2400 Baud. Very high Baud rates usually require matched modems of a specific type at each end of the connection. Smart modems are now available that will search for the fastest connection possible and will uprate or downrate the Baud rate to give the fastest connection/least number of errors combination.

Data size

This is the size of the chunks of information that the modem sends the data in; they can be compared with the words in a vocal communication. The standard unit is eight bits.

Stop bits

These units are added by the modem to indicate the end of a chunk of information similar to the spaces between words in a sentence. The normal default is 1 bit.

Parity

This is a check on whether the data being transmitted are the same as the data received. This technique has been superseded so the normal setting is none.

Handshake

This is the signal used by the receiving computer to halt the flow of data when it is busy writing to disk, processing data, etc. The normal default is XON/XOFF.

File protocol

This is the system by which both computers decide on a standard recognition system to establish the end of a parcel of information and which has replaced the function of the parity bits. The verbal equivalent would be establishing whether a sentence, paragraph or page should be sent before it is checked as being correct. This replaces the parity error checking feature.

File protocols are usually independent of the system so you can choose the most suitable. The receiving system should follow suit.

Xmodem

One of the most commonly used protocols sends data in 128-byte blocks. This is a good system on poor telephone lines due to the fact that only small amounts of bad data need to be sent again. However the system is checking each small amount and sending extra data, so it can be slow.

Xmodem –1 K

Sends 1024-byte blocks and therefore is faster than Xmodem.

Zmodem

A smarter system that works out the optimum block size for the condition of the phone line. The better choice, but if the system is throwing up a large number of retries, try Xmodem.

Using modems outside the UK

When travelling abroad be aware that for n number of countries there will be $n+1$ number of different phone connector types, so carry a range of different connectors. Also some countries get upset at people trying to send data down voice phone lines (for example, Germany requires a permit for using a modem) so check before your visit.

Alternatives to ordinary telephone lines

Beside ordinary telephone connections there are other options.

ISDN (Integrated Services Digital Network)

The concept behind this system is that the user has a dedicated line connected to their place of work. Dialling over this line connects not via the phone network but rather a series of lines designed especially for data communication. The major drawbacks are that the system requires both parties to have ISDN circuits. The system is expensive compared with using telephone connections and the interface is an ISDN card instead of the normal modem. On the plus side they can transmit data at speeds far in excess of any phone connection: data rates of 64 000 bps up to 2 000 000 bps are possible using this system.

ISDN is being used increasingly for the transmission of images around the world. A design company in England used ISDN to receive JPEG compressed images from photographers working on the Whitbread Round the World Yacht Race. Each leg of the race had a newsletter, showing, for example, photographs of prize-winning ceremonies for the previous leg. In one case,

a JPEG compressed image was transmitted from Fremantle, Australia to England in under 4 minutes.

Cellphone

The boom of the 1980s is the Cellphone network, but due to the system used they are unsuitable for data transmission. New systems are being introduced aimed at the data market but standards have yet to be set.

11 Ethics and copyright

In February 1982, the front cover of National Geographic Magazine had a photograph of the Egyptian pyramids, with camels in the foreground, set against the setting sun. The image made a superb cover. However, when originally shot, the pyramids were too far apart to fit the cover format, so they were moved closer together using digital imaging technology. The photographer was understandably angry at the modification of his image. National Geographic now have a policy of not modifying images. The computer used at the time was very large and expensive, and out of the reach of most photographers and magazines. With the advent of smaller, cheaper machines, the ability to enhance and modify images has now been placed in the hands of a great many people. The British tabloid press use the techniques routinely. A photograph on the cover of the *Sun* newspaper, on 30 June 1993, purported to show a monk who had run off with a young woman. However, the image that appeared was actually a composite of three photographs, the woman, the monks head, and someone else wearing a monk's habit. Another example showed the Duchess of York's daughter Princess Beatrice, suffering from chicken pox, who was photographed on a skiing holiday in Switzerland. Two newspapers published the pictures, the *Star* and the *Sun*. The pictures published in the *Sun* showed the princess with far more spots than that in the *Star*! A further example is that of British lorry driver Paul Ashwell who was imprisoned in Greece. The *Daily Mirror* was instrumental in obtaining his release and photographed Mr Ashwell in a *Daily Mirror* T-shirt. The *Sun* newspaper changed the name on the T-shirt to the *Sun*!

These examples lead to inevitable questions of the ethical use of images, and legal questions of copyright violation. With increasing numbers of images being available on CD-ROM, many photographers are worried that their pictures may fall into the wrong hands, and be used or modified without their permission.

The old adage that 'the camera never lies' has never been true. The photographic process is in itself manipulative, recording three dimensional reality on to a two dimensional surface of chemicals. No film gives a true replica of an original scene, merely a representation. Even the use of different films on the same subject can give totally different interpretations of that subject, whilst photographers routinely use different focal length lenses to distort perspective in order to give a different emphasis to images. Even the act of framing an image in the camera to exclude part of a scene, or cropping it afterwards can alter an image's message. Also, since the very early days of photography, photographers have constructed images, either in the camera

by double exposure of the film, or in the darkroom by printing several negatives on to the same sheet of paper. Oscar Rejlander was an expert in this area, constructing some very complicated images in the 1850s. In other instances, photographers have manipulated their subjects, perhaps to re-create an event after it happened. Much controversy still surrounds Joe Rosenthal's famous image of the 'Raising of the Flag at Iwo Jima', and Robert Capa's image of a Spanish soldier being shot, and whether or not they were posed for the camera. Photographs and television coverage of police officers removing human remains from a house in Gloucester in March 1994 certainly were posed for the press.

Electronic imaging in the form of television has been with us now for over 50 years, and post-production manipulation of television images is very widespread. Adding new backgrounds to scenes, removing telegraph wires and even removing or adding foliage to change the season or the period are often the norm in television drama production units.

So image manipulation is not new, but it is perhaps now easier and quicker than ever before. The British press at present are being closely scrutinized for their intrusion into the private lives of the Royal family and other famous people, and have agreed to set up a self-regulatory body, although it is unclear how it will deal with digital manipulation of images. Hopefully this will also oversee the use of digitally manipulated images, and ensure that they are used appropriately. Many publishing houses in the USA have issued statements outlining their own policy regarding image manipulation. One produced by the San Gabriel Valley Newspaper Group states:

> the purpose of all editorial photography is to convey the scene as accurately as possible. There is no such thing as an innocent alteration of a news photo. There will be no alteration of any photo by any means, digital or conventional, for any purpose other than to enhance accuracy or to improve technical quality. If there is an element of a photo which is deemed unsuitable for publication, then that element may be cropped out, or another frame chosen. Cloning and similar digital or conventional techniques are specifically forbidden to be used for this purpose. If the offending element cannot be cropped out and there is no other suitable frame available, then no photo will run.
>
> Changes may be made, for accuracy – enhancement purposes only, under the guidance of the photographer who took the picture, or some other editorial staff member who was present at the original scene. Colour balance is to be achieved by using known colours such as white or a flesh tone. Colours will not be enhanced for the purpose of making a photo aesthetically 'look better'. Photos may not be reversed left-to-right.

The illegal use of images, or infringement of copyright is another issue altogether. The Copyright, Designs and Patents Act of 1988 states clearly that the copyright holder of an image has the exclusive right to copy or publish it. Copyright is infringed when someone other than the copyright holder copies or publishes that image. The term 'copying' is defined in section 17

of the Act as 'reproducing the work in any material form, including storing the work in any medium by electronic means'. Thus, even inputting the image into a computer is as much an infringement of the Act as reproducing it in a book or magazine. Clause 13 relates specifically to electronic storage: 'Except for the purposes of production for the licensed use(s) the photographs may not be stored in any form of electronic medium without the written permission of the photographer. Manipulation of the image or use of only a portion of the image may only take place with the permission of the photographer'.

It does not necessarily need to be the whole of an image that is used or copied in order to infringe copyright, but a 'substantial part of it'. Substantial is not defined, but many photographers are worried that parts of their images may be used to create new images – anything from cloudy skies to tropical beaches. There are no objective rules as to what does constitute a 'substantial' part of an image, but in general, if the part used is recognizable, then permission from the copyright holder is required in order for it to be used. Similar problems have arisen in the music industry, where short sections of a piece of music have been joined together to form a new piece.

The Copyright Act introduced an innovatory area, that of the concept of 'moral rights'. Photographs manipulated without the consent of the copyright holder may infringe the moral rights of the photographer, even if they no longer own the copyright. Under the Copyright Act, photographers have the right not to have their work 'subjected to derogatory treatment'. Section 80(2)b of the Act defines derogatory treatment as: 'distortion or mutilation of the work, or treatment that is otherwise prejudicial to the honour or reputation of the author.' No case has appeared in the courts yet, and it is interesting to speculate how a court would interpret this sub-section of the Act. The question of what exactly constitutes manipulation is difficult. Does making an image brighter or darker for better reproduction mean that it has been manipulated? Does sharpening or blurring of the image constitute manipulation? Many images have blank space added on to the top to give room for a magazine title – is this manipulation? Obviously there is the question of degree, and whether or not the original composition or 'feeling' of the image has been altered.

One interesting aspect of image manipulation is that of the copyright of the manipulated image. If an image is constructed from two or three separate images, each of which has a copyright owner, their original copyright remains unaffected. However, the person producing the manipulated image becomes the copyright holder of that image. Thus an image may have several copyright owners, all of whom will need to give permission for an image to be reproduced.

Picture libraries, entering the world of digital storage, are obviously concerned that producing CDs with high resolution images good enough for publication will lead to use of those images without payment. Several methods are available of making those images inaccessible. CD-ROMs are available

containing hundreds of typefaces. These can be viewed on screen but if the client wants to use them, he has to make the required payment to the company, who will then issue a password to access the required font. One interesting case is that of the US stock library FPG International, who in February 1994 filed a $1.4 million lawsuit against the newspaper *Newsday*. They alleged that the newspaper scanned two images from its printed catalogue, and then digitally altered them as part of a computer-generated montage.

British photographers should also be aware that the Copyright Act applies only to images used in the UK and that all countries have differing views over what constitutes copyright, some countries do not recognize copyright in any form whatsoever. Most countries though, are signatories to the Berne and Paris Conventions, which impose upon signatory countries the obligation to uphold and respect the laws of all the other countries who have signed. This has clear implications in the implementation of international image distribution by electronic methods. For example, a CD of images with limited usage rights could be duplicated in such a country and sold in a new form.

American copyright law ranges from the sensible to the absurd. For example the trademark 'simply powerful software' is a registered name. In the field of photographic images they have the rule 'That when it's created it's copyright' and no piece, however small, of any image can be used without permission.

In practice the best protection for image owners is to establish clear and simple usage rights for an image with the image user. These fall into the following categories:

1 the right to reproduce the image;
2 the right to distribute the image;
3 the right to display the image publicly;
4 the right to create derivative works based on the image.

Each of these rights can be divided or limited in any of several ways – the number of times the image may be published and the type of publication the image may appear in – and in the case of distribution, the length of time that the image may be marketed and the percentage of usage fee kept by the distributing party.

The major factor to consider is that with digital imaging the duplicate of an image file is a perfect replica of the original image. Until now photographically copied images always gave themselves away by a degeneration of quality, but now, with digital technologies, the hundredth copy of an image is identical to the original.

Safeguarding images

With the tremendous advances in electronic storage and distribution of images, a few suggestions and words of advice are offered below to photographers and copyright holders to help safeguard their property.

1 Retain the high resolution file until payment

If digital images are to be distributed as samples or proofs, a low resolution copy of the file should be sufficient for the potential purchaser to assess the suitability of the image. If the purchaser requires time to pay, state in any contract that copyright is only transferred on receipt of payment (see Plate 19).

2 'Watermark' the image

This operation can be simply carried out in an image manipulation program such as Photoshop. Select a large typeface with white ink, next select the composite option (edit menu composite controls) make the text some arbitrary transparency between 40% and 20%, position the text on to the page and deselect it. This will have the effect of a watermark over the image. The effect works best with large type and a single word such as 'proof' or 'copy' (see Plate 20). This system is being employed by a number of picture libraries.

3 Add a logo

Design a small logo or electronic business card and digitally paste this on to the image file before dispatch (see Plate 21).

Although these measures will protect the image, they have the disadvantage that the recipient will eventually require a high resolution copy of the file at a later date. The alternative is to release the complete file to the client, a process no more damaging than trusting them with an original transparency. The best practical advice here is to clearly mark the file in some way with details of its ownership. Although none of the following methods will prevent use of the file they will all be helpful in the case of any dispute.

4 Add your details to the image

In the application that you are using find the command to increase the size of the 'canvas'. Add 5 or 10% to the height of the image. This will appear as white space at the bottom of the image. Details of the photographer or agency can now be added in this new area (see Plates 22 and 23).

5 PhotoCD

The professional PhotoCD system is capable of recording all copyright information on the disk as a permanent feature. This information should be given to the bureau at the time of scanning for inclusion on the disk. This information is displayed when the images are accessed (Plate 24).

6 Clearly mark all disks, etc. with copyright details

Place labels on floppy disks, mark all disk envelopes or CD cases with a copyright notice, your name, address and phone number.

7 Add information

With the Macintosh platform, you can add copyright details, your name, address and phone number in the comments box associated with the file. This is done by selecting the file and choosing 'get info' from the file menu (see Plate 24).

8 Name the file

Depending on the system, use your name or initials as part of the file's name.

12 The future

With rapid developments in electronic imaging, many people are asking the question as to how long conventional silver-based film will last. Film of course relies on silver, an expensive precious metal, and huge amounts of potentially dangerous and polluting chemicals are consumed in production and processing. As all photographers know, film is capable of recording a huge amount of information, with excellent degrees of sharpness and colour fidelity. A 35 mm slow speed, fine grain transparency can record a phenomenal amount of information. To achieve approximately the same amount of information digitally would require about 18 million pixels, giving a file size of around 72 Mb! This obviously takes up far more space, and costs far more than a piece of 35 mm film. It is likely that for many purposes, silver-based film will continue to be used for the foreseeable future. In the cinema for example, even though many film sequences for films such as *Jurassic Park* and *Terminator II* are either computer generated or manipulated, only film (at present!) can give the quality required for large screen projection.

Fuji have recently been quoted as predicting the death of silver film within 15 years for still photography within the amateur market. US military organizations expect to ban all wet photographic processes by the end of the decade. These predictions are obviously dependent upon the development of new digital cameras, with such factors as price, quality and ease of use all affecting the market. In the 1950s, with atomic weapons an ever present threat, the Army Signal Corps feared that silver film might be fogged by atomic explosions. They funded research into a new silverless imaging system, which became known as the Xerox process! The first microwave ovens were very expensive. Now, with large consumer demand, they are relatively cheap. For electronic cameras to take over from film cameras will mean persuading huge numbers of people to buy new cameras. The same argument applies to high definition television, where large numbers of consumers will need to buy new televisions if they are to benefit from the new technology.

Camera developments

New CCD chips are currently under development which will mean huge increases in the quality of digital images. Kodak have demonstrated a 35 mm size 6 million pixel chip which gives outstanding quality, and it is likely that these developments will continue apace!

At present, CCD imaging chips, are put into conventional single lens reflex and other types of camera. They are, of course, also found in video cameras and camcorders. One possibility is for new hybrid cameras to be developed fulfilling two functions of moving video images and still digital pictures.

Storage

New storage media are likely, and a move away from hard disks on to Smart card storage is imminent. These act in much the same way as credit and phone cards.

The images themselves

Has the technology spawned new images or merely made old ideas easier? What of the images produced with the aid of the new technology. Are new images being created as a result of the technology, or is it now just much easier to produce more of the same? In a now famous BBC television programme, QED, in 1992, Richard Hamilton, the pop artist, was shown constructing a collage on his computer screen, using images from digital cameras, or scanned from various sources. The image, depicting his view of the 1990s mirrored a collage he produced in the 1960s, using traditional cut and paste techniques. The 1960s image was unique, and could only be reproduced via photographic copying. At the end of the television programme, viewers were invited to write in for one of several thousand identical laser copies produced from the computer images. Interested viewers jammed the BBC switchboard for three hours after the programme!

The rate at which electronic imaging is used by the photographic and media industry is dependent on the cost, quality and convenience of the systems. The difference between playing with images on a computer and installing a commercially viable photographic imaging workstation is as vast as the difference between a home darkroom and a commercial photographic company. The major consideration in equipping any enterprise with computers is whether or not they will make a positive contribution to the work, and profit, of the company. Another important factor is how much of the process you wish to carry out in-house.

Before launching into the world of digital imaging it is worth considering the motives behind any investment. A number of photographers have found that the digital imaging system is an expensive addition to their business appearing as a minus on the company profit sheets instead of a plus.

To try to give a perspective on how digital imaging can be an advantage the issue can be broadly divided into two areas:

1 The digital system

This is the nuts and bolts, the hardware and software that enable images to be captured, manipulated and printed. This is the equipment that manufacturers would like to sell. It corresponds to cameras and camera equipment and enables the application.

2 The application

This is the use to which the equipment is put – the product that the photographer is selling to the client. In order to be viable the digital system must offer an advantage to both the photographer and the client above and beyond the service that normal photography can provide to justify the cost.

The cost

The major factor to be considered when investing in computer technology is that, unlike a camera or lighting system the investment will have to be repaid in a very short time scale. In the computing industry it is a recognized fact that machines double in power and capacity and halve in cost every two years. Unlike a camera system that will serve for ten years or more a computer that is two or more years old will probably serve better as a doorstop than a working unit.

Applications

The key to obtaining the maximum potential from digital imaging is to initially establish your application. This has to offer substantial benefits over conventional photography to justify the cost. Taking the various areas of digital imaging and examining applications that exploit the advantages of the medium.

Digital cameras

The major advantage to a digital camera is the speed of obtaining an image and transmitting to a remote site. An obvious application is news events, and Associated Press has commissioned its own digital camera and transmission unit for its members. A number of companies specialize in covering specific events such as sports events around the world and transmit their pictures back to a subscription service via modem link over telephone lines. The images are available to any users of the system, and are available within minutes of the photograph being taken. Digital cameras are being installed on theme park rides to provide images of the passengers on-route available at the conclusion of the ride.

The immediacy of the imaging process can provide financial benefits in the portrait studio where the sitter can review the actual images on screen without any delay, and pay for selected enlargements without the need to return to the studio at a later date. This scenario provides a substantial improvement in cash flow for the photographer. Markets such as passport and identity photography can provide instant results without waste material of any sort.

Users of large amounts of images, such as the production companies involved in catalogue work, currently have to pay a substantial amount to have all the film images scanned to produce digital images for assembly in desktop publishing. To use a photographer who can provide the required images in the correct format to start with can prove a strong selling point. Substantial savings are also made by negating the need for Polaroid prints.

The audio-visual market is also a large user of photographic images and is increasingly using computer presentation packages for its clients. This product market has traditionally been served by the rostrum camera users, and displayed on 35 mm projectors, but is now increasingly utilizing computer projectors and television monitors. The display technology may change but the photographers ability to produce quality images is still required.

Digital manipulation

It is difficult to judge the potential market for manipulated images. Traditionally the field has been dominated by the high end systems such as the Quantel Paintbox, Kodak Premier or Silicon Imaging workstations. Due to the high cost of such equipment and the skilled technicians needed to operate them the work has been expensive, and limited to high cost projects such as major advertising campaigns. The work held a kudos and premium price by nature of its rarity value. How long this will last when costs drop dramatically is open to debate.

The major problem with image manipulation packages is that they can become a time trap, the package offers such a wide range of tools and functions that the operator can spend hours tweaking an image and applying different effects. No self-respecting photographer would go into a darkroom with a negative and subject it to every known form of chemical process, variation of exposure, photographic grade of paper just to see what the result is. However this is just what many photographers do given a computer.

In order to be a commercially viable application the service offered needs to be performed in a set number of stages, in a repeatable manner, in a method which can be priced to provide a profitable service. Any photographer offering to retouch or alter an image needs a great understanding of the length of time the process will take to cost the job correctly. The customer or client also needs to be made aware of the time involved and the potential cost before the work is started. Potential markets include the retouching

of old, damaged or faded photographs (copyright respected), and wedding photographers who have photographed a large group of guests only to find one person has their eyes shut! The image of that person can be taken from subsequent negatives and pasted into the original shot. The makeover portrait market is also an area where retouching skin blemishes, tweaking a little weight off the figure or just enhancing nature a little could reap significant benefits. Providing consistent coloured or textured backgrounds or even company logos for a range of products could also add value to the service offered by a studio photographer. CD-ROMs are available with hundreds of high resolution, copyright free backgrounds. Any number of effects filters are available to the portrait photographer to turn a photograph into an image resembling a water-colour painting, pencil sketch, oil painting or charcoal drawing (see Plates 25–28).

Digital output

This is the area which lags behind the current photographic technology, not in terms of quality but in terms of size, speed and cost. Currently there is no cost effect method in the digital world of producing photographs larger than A4. Also the production of photographic quality images on dye sublimation printers is slow (typically three to five minutes per image). Although this speed compares favourably with individual production methods there are no economies of scale to be made, so a hundred images will each take three minutes. The market is developing devices to print digital images to conventional photographic paper but until these become available at a reasonable cost the only alternatives are to find a bureau with a digital film recorder to produce a negative which can then be enlarged using a conventional photographic process. Several photographers are using dye sublimation prints where speed and quantities are reasonable – wedding albums and reprints for example.

Hidden costs

Having established the potential application the cost of the service must be calculated. This must include not only the initial investment, but all the extra 'hidden costs':

Depreciation

As already mentioned the computer industry is constantly improving functions and reducing costs every two years or so. The current tax laws on attributing the investment cost of equipment do not allow for such short periods. The resale value of old equipment can be considered as almost negligible. All these factors must be taken into account when costing the work carried out on any system.

Computer memory

Memory SIMMS are expensive, and imaging files require large amounts of memory. The extra cost of equipping a normal computer with sufficient memory for imaging can double the price.

Training

Getting to know a piece of software sufficiently to enable commercial work to be produced can take considerable amounts of time. Speed of operation is important to a successful enterprise, and the establishment of the quickest method of performing any imaging operation will pay in real terms. Consider training, but investigate any package offered to ensure that it covers your level of experience and offers value for money. If you employ staff consider their training needs not just in image related programs but in basic computer training as well. Following a one day training course for example, it is essential that staff are given time to become familiar with new software.

Software/software support

A copy of each software package used must be purchased for each computer in the company. Most companies offer free software support for a given time period on purchasing and registering software. Extended support can be purchased for a nominal fee.

Service contracts

The amount of time taken to repair a unit relates directly to its productivity. Beware a low initial equipment quote which is an incentive linked to a very expensive service contract.

Storage

The size of digital files means that the floppy disk method of storage is not a viable solution to storage. Greater capacity is required and CD WORM drives, optical storage, removable hard drives or tape storage are needed to transport the files to the customer. Most users will store an image on the internal hard disk of the computer. Should anything happen to this disk all the information will be lost. The solution is to 'back up' the disk drive, making a complete copy of all the information present on the computer and then store it in a safe place away from the computer.

Insurance

The photographic industry in general is very careful when storing photographic equipment, locking cameras away in steel cupboards, etc. The

problem with a computer system in that removing the computer from the work area at the end of the day and locking it away is not a practical solution.

Make sure that all the equipment is indelibly marked with your name and postcode, visibly placed to deter theft. A number of devices fix the computer to the work surface with cables, bolts or glue. The best way may be to use a padlock system that fixes to the case of the computer and monitor but allows removal if needed. Additional alarm units that sense the unit being moved or unplugged are on the market. The general rule is that security around the premises must be substantially increased if expensive computer equipment is around. Install video cameras or motion sensors and increase the level of locks on doors and windows. Check with your current insurance to see how installing computers will affect your insurance. This may sound paranoid but everyone in the industry has stories of computer theft that they or a client have experienced in the past two years. One magazine publisher lost an entire week's production through the theft of several computers! A handful of memory chips can sell on the black market for several thousand pounds and are untraceable.

Software

Software changes at regular intervals. The process is known as upgrading and a fee is charged for each upgrade. The system starts with a piece of software known as an Alpha version which is the copy produced by the software company to see if the product is viable. Alpha versions are not normally seen outside of the company involved. The next step is a Beta version, copies of which are distributed to selected users to test and discover any faults ('bugs'). The next step is to release or 'ship' a full version – usually called version 1. Any faults or 'bugs' in this software that customers find will be corrected in a release of a 'bug fix' usually distinguished by a decimal point in the version number. So the corrected software for version 1 will be 1.1 and then 1.2, etc. The theory was that software houses charged a fee for full upgrades (whole numbers) and gave the 'decimal point' versions away free when the user registered their software. Software houses now adopt a numbering system known only to themselves, but distinguish their new offerings with the term full upgrade (this implies a fee) or just an upgrade (which implies a fault on the original offering). The only substantial conclusion to be drawn from the whole system is that the pressure on software houses is to produce newer versions of their software in shorter periods of time. Therefore, as a user there are some important 'rules' to observe when buying or upgrading software:

Rule 1: Never buy version 1 of a program if you can possibly avoid it. Let someone else find all the faults first!

Rule 2: Never remove the old version of any software before running the new version for at least a month.

Productivity software

A number of companies offer software packages that record a series of operations. PhotoMatic, DeBabelizer or Apple's Photoflash all allow the user to record the stages in manipulation or processing of an image and then apply these same operations to other images under automatic control of the computer. This allows the operator to process images overnight or during a period when the computer is not otherwise being used. There are also packages available that use a simple programming language to create 'macros' (a series of operations or processes) that can be assigned a keyboard combination. One result of this is that, for example, pressing 'shift' and the number one key together could trigger such a macro to apply a sharpening filter, size an image and then save it in a JPEG file format.

In conclusion, it should be noted that digital imaging, despite the advantages will prove more expensive than its conventional photographic counterpart. Therefore any digital service must carry a price premium to be a viable concern.

One thing that must never be forgotten is that electronic imaging requires very much the same skills of the photographer in terms of lighting, composition and the like. Wedding photographers will still need to be able to pose groups of people, and use lighting to effect. Medical photographers still need to understand their subject, and treat it with great respect. Only the recording medium has changed. Maybe in the not too distant future, photographers, or image producers as they may come to be known, will wonder what all the fuss was about, and treat electronic imaging and computers as just more tools in their armoury for producing images for their clients. Perhaps the revolution that everyone is talking about is no more than an evolutionary step – after all, we don't shoot on glass plates any more!

Glossary of terms

Algorithm
A set of rules (program) by which the computer resolves problems

Aliasing
Refers to displays of bitmapped images, where curved lines appear to be jagged due to the way they are composed of square pixels

Analogue
A signal that simulates sound or vision by electrical analogy, e.g. variations in voltage producing corresponding variations in brightness, or vice versa

Aspect ratio
The relationship between the height and width of a displayed image. For television it is 3 : 4

Baud rate
A measurement of the speed at which information is transmitted by a modem over a telephone line. Baud rates are in terms of bits per second (bps). Typical speeds are 1200, 2400 and 9600 Baud

Binary
Numbering system using two digits, 0 and 1. In imaging terms, black or white

Bit
Short for binary digit – a single number having the value either zero or one. Eight bits make up one byte

Bitmap
A binary representation of an image, in which each bit is mapped to a point on the output device, where the point will either be on (black) or off (white)

Bits per pixel (bit depth)
The number of bits used to represent the colour value of each pixel in a digitized image. 1 bit/pixel displays 2 colours, 2 bits 4 colours, 3 bits 8 colours, etc. In general, n bits allows 2^n colours. 24 bit displays show 16.7 million colours

Byte
The standard unit of binary data storage in memory or disk files: containing 8 bits, a byte can have any value between zero and 255

CCD
Charge Coupled Device – a solid state image pick-up device that produces an electrical output analogous to the amount of light striking each of its picture elements

CD-I
Compact Disc Interactive – a version of the compact disk carrying text, audio and vision for interactive uses

CD-ROM
A form of compact disk used for storing digital data of all types (e.g. Kodak PhotoCD). They are capable of storing 550 megabytes, but cannot be updated or changed by the user

CD-R
A recordable (once only) CD disk, *see* WORM

CMYK	**Cyan, Magenta, Yellow and Black** – The four colours used by printers to produce colour illustrations
Colourspace	A three-dimensional space or model where the three attributes of colour, hue, saturation and brightness can be represented ,e.g. CIE Colour Space, Munsell Colour Space
Colour trapping	A printing term referring to the solution to slight mis-registrations in the printing process. If two colours are mis-registered, a white line will appear around the object. Trapping is the process of adding extra colour to fill in the gap created. Programs such as Photoshop have trapping capabilities
Compression	A digital process that allows data to be stored or transmitted using less than the normal number of bits. Video compression refers to techniques that reduce the number of bits required to store or transmit images. There are several types, of which the JPEG standard is becoming widely accepted for imaging
DCS	**Digital camera system** – the name for Kodak's digital camera, based on the MegaPixel imager attached to conventional Nikon cameras
Digital	A signal that represents changes as a series of discrete pulses
Digitize	Convert into digital form. Digitization is subdivided into the processes of sampling the analogue signal at a moment in time, quantizing the sample (allocating it a numerical value) and coding the number in binary form. A digital image is made up of a grid of points. There is no continuous variation of colour or brightness. Each point on the grid has a specific value. Digital images are recorded as data, not as a signal
Dithering	A method for making digitized images appear smoother using alternate colours in a pattern to produce a new perceived colour, e.g. displaying an alternate pattern of black and white pixels produces grey. Has also become widely used as a reference to the process of converting greyscale data to bitmap data, and thus to a reduced grey tone content
Dots per inch	The measurement of a printer's resolution – the maximum number of dots that can be printed per inch of page, e.g: 300 dpi
EGA	**Enhanced Graphics Adapter** – a standard that specifies 640 x 350 pixels with 16 colour capability from a palette of 64 colours
EPSF	**Encapsulated PostScript Format:** refers to a standardized disk file format used widely in desktop publishing

software. It is a file containing PostScript (qv.) commands, with additional data to enable it to be incorporated in other documents. The main data is 'encapsulated' by these additional commands

Ethernet
A system of networking computers and peripherals together to send data rapidly to each other

Field
Half of a picture, composed either of the odd or even line scans which interlace to form a complete frame

File formats
The overall format in which an image file is saved. Choosing the correct format for saving images is important to ensure that the files are compatible with various software packages. Examples are: TIFF, EPS, PICT,

Filter
A software routine which modifies an image by changing the values of certain pixels. Examples are sharpening filters and distortion filters

Floppy disk (or 'diskette')
The name given to a 3.5" disk used for storing relatively small amounts of computer data. There are two capacities available, double density (storing approximately 700 K) and high density (storing approximately 1.4 Mb)

Floptical
The name given to a 3.5" magneto-optical disk

Frame
Video data is transmitted as two interlaced fields which make up a frame. In a 50 Hz system, a complete frame is transmitted every 1/25th of a second

Frame grabber
Hardware that takes the analogue signal from an imaging device and digitizes the signal into RAM

Gamma
The relationship between input data from an electronic image, and output data telling the monitor how to display an image

Gamut
The range of colours which can be displayed or printed on a particular colour system

GUI
Graphical User Interface – a computer interface such as the Macintosh system, or Microsoft Windows, which uses graphical icons to represent computer functions

Hard disk
The term used either for an internal or external rigid disk used for reading and writing computer data. Many different capacities are available, including several types which are encased in plastic, and can be removed from the drive mechanism (e.g. Syquest™)

Histogram
A graphical representation of an image showing the distribution of grey or colours levels within an image

Image processing
Techniques that manipulate the pixel values of an image for some particular purpose, e.g. brightness or contrast correction, changing the size (scaling) or shape of images, or enhancing detail

Imagesetter A high resolution device producing output on film or photographic paper usually at resolutions greater than 1000 dpi. Usually a PostScript device

Interpolation A method for increasing the *apparent* resolution of an image whereby the software averages adjacent pixel densities and places a pixel of that density between the two

ISDN **Integrated Services Digital Network** – a telecommunications standard allowing digital information of all types to be transmitted via telephone lines

ISO speed The rating applied to photographic emulsions to denote the relative sensitivity to light. Most digital cameras have 'equivalent' ISO ratings, to enable comparison with film

JPEG **Joint Photographic Experts Group** – a widely used compression routine used for still photographic images

LUT **Look Up Table** – a preset number of colours used by an image

LZW **Lempel–Ziv–Welch** – a lossless compression routine incorporated into TIFF

Mavica **Magnetic Video Camera** – the first still video camera, produced by Sony in 1981

Modem **MOdulate and DEModulate** – a device for converting digital signals into analogue for the purpose of sending data down telephone lines

Multimedia The combination of various media, e.g. sound, text, graphics, video, still photography, into an integrated package

NTSC The TV standard used in the USA and Japan. Has 525 lines/60 fields

Object-oriented A graphics application, such as Adobe Illustrator, using mathematical points based on vectors to define lines and shapes

OCR **Optical Character Recognition** – software which, when used in conjunction with a digital scanner converts pages of typescript text into editable computer data

Paint A program which defines images in terms of bitmaps rather than vectors

PAL The TV standard used in the UK and much of Western Europe. Has 625 lines/50 fields

PEL *see* Pixel

PhotoCD System of recording film images on to a CD disk

Pick-up device A camera tube or solid state image-sensor that converts light on its target into an electrical analogue. In the case of solid state devices this is a matrix of minute photosensitive cells

PICT The name given to Apple's internal binary format for a bitmap image. A PICT image can be directly displayed on a Macintosh screen, or printed. The resolution is relatively low, and the images cannot be scaled to another size without loss of detail

Pixel **Picture element** (sometimes called a 'pel') – the smallest area capable of resolving detail in a pick-up device, or displaying detail on a screen – fixing the maximum horizontal resolution. Conventional TV/video does not have pixels. The image from the CCD in a camcorder is in the form of pixels, but is converted to a continuous video signal

Pixellation A subjective impairment of the image in which the pixels are large enough to become individually visible

Platform The type of computer system, e.g. Macintosh or IBM PC compatible

Plug-in A small piece of software often supplied with scanners and other peripherals, allowing the user to access and control those devices through an image processing software package such as Adobe Photoshop. Many third party manufacturers (such as Kai Power Tools™) market extra filters and other special effects as plug-ins to programs like Photoshop. When installed, the plug-in becomes an item on one of the program's menus

PostScript A computer language used in laser printers to simulate the operations of printing, including placing and sizing text, drawing and painting, graphics, and preparing halftones from digitized greyscale images. It has become a standard way of 'driving' high quality printers

RAM **Random Access Memory** – temporary memory created when the computer is switched on. The size of images which can be opened is dependent on how much RAM is installed in the computer

RIFF **Raster Image File Format** – an image file format for greyscale images. Has the chief advantage of offering significant disk space savings by using data compression techniques

RIP **Raster Image Processor** – a device which converts a page description language such as Postscript into the form necessary for output by an imagesetter

RGB **Red, Green, Blue** – the three primary colours used in monitor displays

ROM **Read Only Memory** – a memory unit in which the data are stored permanently. The information is read out non-destructively, and no information can be written into memory

Resolution The ability of a recording system to record and reproduce fine detail. There are two resolution figures in video: horizontal and vertical. Video resolution is given as lines per picture height. In digital systems, resolution is the number of pixels on a display surface. CRT resolutions are usually given as number of pixels per scan line, and the number of scan lines, e.g. 640 x 480 (NTSC), 768 x 512 (PAL). Printer resolutions are usually given as dots per inch, e.g. 300 dpi. A modern CCD may have resolution figures of 600 000 pixels, giving 1212 pixels horizontal, by 500 vertically delivering 480 lines of horizontal resolution

SCSI **Small Computer Systems Interface** – an industry standard for conecting peripheral devices to computers

SV **Still Video** – an electronic still camera employing a solid state pick up device in the focal plane, and recording the analogue signal on an SV floppy disk (or memory card) for subsequent playback. The disks can record 50 fields, or 25 frames together with a limited amount of audio. The disks can be erased and re-recorded

Syquest™ Proprietary name given to a range of removable hard disks

Thumbnail A very low resolution version of an image used for sorting and finding images

TIFF **Tag Image File Format** – a standardized image file exchange format. It has been adopted by many manufacturers who support high resolution graphics. TIFF files cannot be printed directly – they must be loaded into an application first

Unsharp masking A procedure for increasing the apparent detail of an image, performed either by the input scanner, or by computer processing

VGA **Video-Graphics Array** – an electronic display standard that defines a resolution of 640 x 480 pixels with a 16 colour capability, and 320 x 200 pixels resolution with a 256 colour capability from a palette of 256 k colours

Video The analogue electrical signal generated by an image sensor

Virtual memory A technique for increasing the apparent size of memory available by using memory from the hard disk. It is generally very slow

WORM **Write Once, Read Many Times** – an optical disk that can only be recorded once with data. This cannot be erased or changed

WYSIWYG **What You See Is What You Get** – refers to the relationship between the screen display and final output

Index

The CD

To access this disk you require the following equipment

either an Apple Macintosh with CD drive capable of reading XA ROM type disks and a monitor capable of showing thousands of colours*

or an IBM compatible 386 computer, or faster running Windows 3.0, with CD drive capable of reading XA ROM session disks and a monitor capable of showing thousands of colours*.

The disk will appear slightly different with each type of system

For the PC user:

Place the disk in the CD ROM drive:

The directory PC contains sample software which has all the functions of the commercial package but will not allow the user to save images.

In File Manager select the drive for your CD ROM eg. D:

From the directory listing choose PC directory;

then Photoshop;

then disk 1;

then execute the SETUP.EXE file.

Adobe tryout software will then install to your hard drive. In order to run the software you will need to re-start Windows.

The installer for Photoshop 3 is:

PC/PHOTOSHP/DISK 1/SETUP.EXE running this program will install the tryout version on your hard disk. Also included are tryout versions of the following:

Streamline - a program that coverts bitmap to vector drawing

PC/STRMLINE/SLSETUP.EXE

For Mac users:

All the programs are in the Mac folder

An install alias resides in each folder or the program where possible has been expanded on the disk to avoid the user having to run an installer program. Apart from the Adobe software NIH Image is included as freeware. This is a full working version of a 256 colours image analysis program.

For all users:

The Images directory contains samples from several different types of digital cameras and samples of each of the resolutions of image from PhotoCD and ProPhotoCD image packs along with the image packs themselves these image packs can be opened by Photoshop with an open command. Image packs are identified with the name IMGnnnn.PCD where nnnn is the number of the image. Due to the structure of Pro PhotoCD it is not possible to supply the highest resolution file without a PhotoCD disk so the image pack contains only 5 resolutions plus a 72Mb tiff file. Due to the large size of some of the camera files, larger files have three versions in their directories

1. the image file at full resolution
2. a file called small.tif a version of the original sampled down to a smaller version
3. sample.tif this is a small section of the original to show the true quality.

For users with 256 colours only, try opening images and converting to indexed colour using the Mode menu indexed colour option in photoshop.